Lesley Dill

PERFORMANCE AS ART

René Paul Barilleaux
Jody Blake

McNay Art Museum | San Antonio, Texas

The Alturas Foundation and Mitcham Partners are lead sponsors.

The Elizabeth Huth Coates Exhibition Endowment, the Arthur and Jane Stieren Fund for Exhibitions, the Flora Crichton Visiting Artist Fund, the Ewing Halsell Foundation Endowment for Visiting Artists, and the Director's Circle are providing additional support.

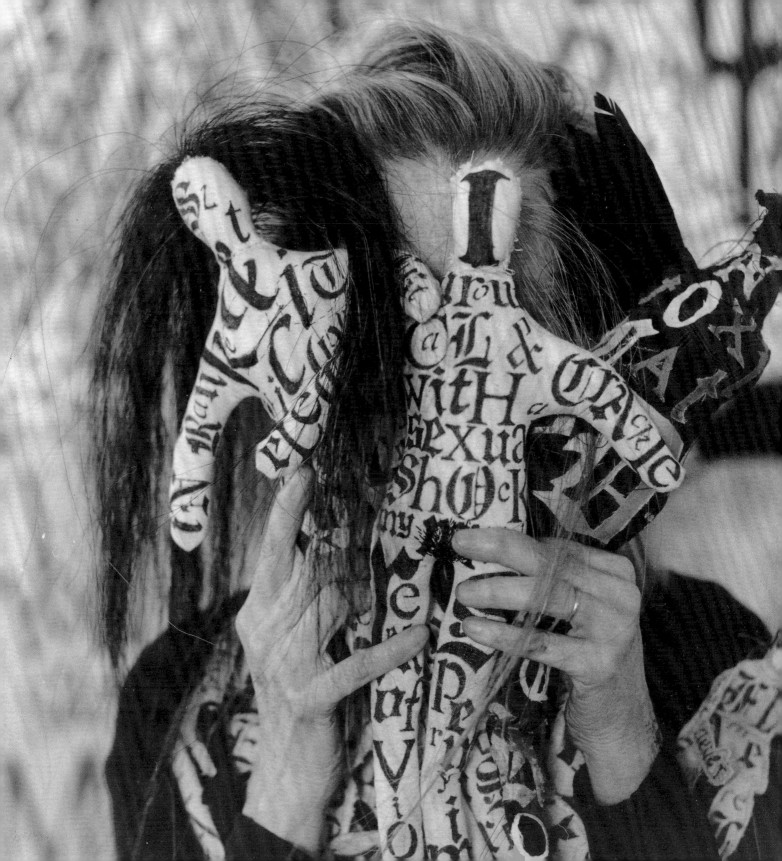

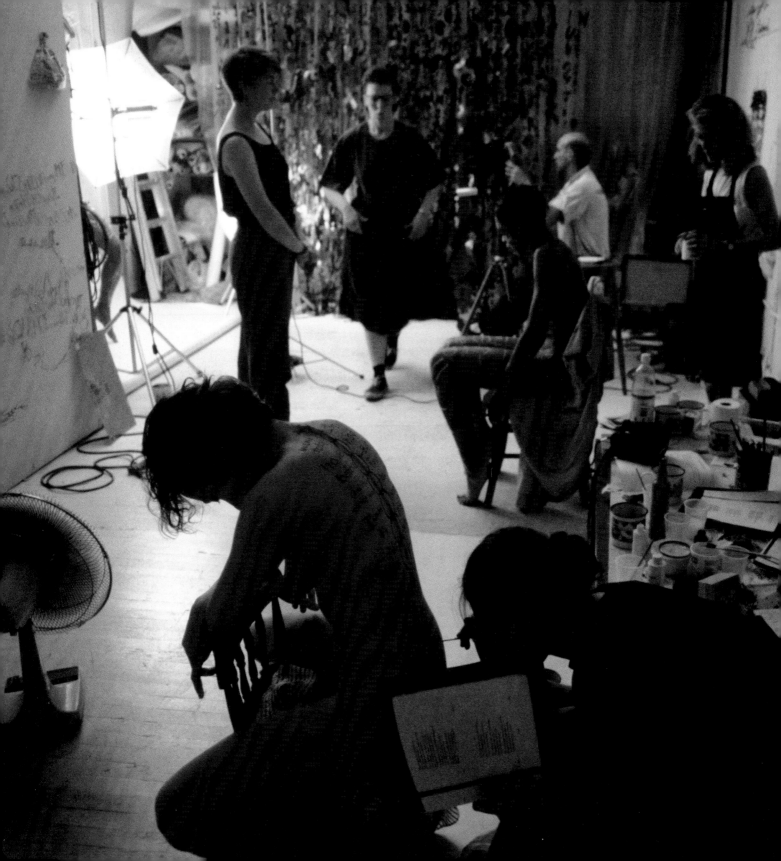

FOREWORD

*A*mong museums of modern art, the McNay Art Museum is unique in having both a strong program in contemporary art, including painting, sculpture, and works on paper, as well as a strong program in contemporary scene and costume design, as the home of the Tobin Collection of Theatre Arts. Thus the McNay is the ideal institution to organize *Lesley Dill: Performance as Art,* and presents a perfect setting for this exhibition.

I congratulate René Paul Barilleaux, Chief Curator/Curator of Art after 1945, and Dr. Jody Blake, Curator of the Tobin Collection of Theatre Arts, for creating this exciting project that connects two strengths of the museum in a visually arresting and thought-provoking exhibition devoted to a special aspect of Lesley Dill's work. Their collaboration to produce this exhibition and publication as well as the accompanying performance of *Drunk with the Starry Void*, is a model of its kind.

Seven years ago the McNay was pleased to acquire Lesley Dill's *Vision Catcher*, 1995, a mixed media work of oil and thread on tea-stained muslin, as a purchase with funds from the McNay Contemporary Collectors Forum. Dill subsequently participated in a conversation at the museum about her work. Crossing the very porous borders in contemporary art between traditional media, with language as a unifying theme, she uses a wide variety of materials and techniques in service to her expressive purpose, whether for a gallery or a performance space. The McNay is delighted to offer further insight into Dill's art in this focused exploration of her performance-based body of work.

—WILLIAM J. CHIEGO
Director

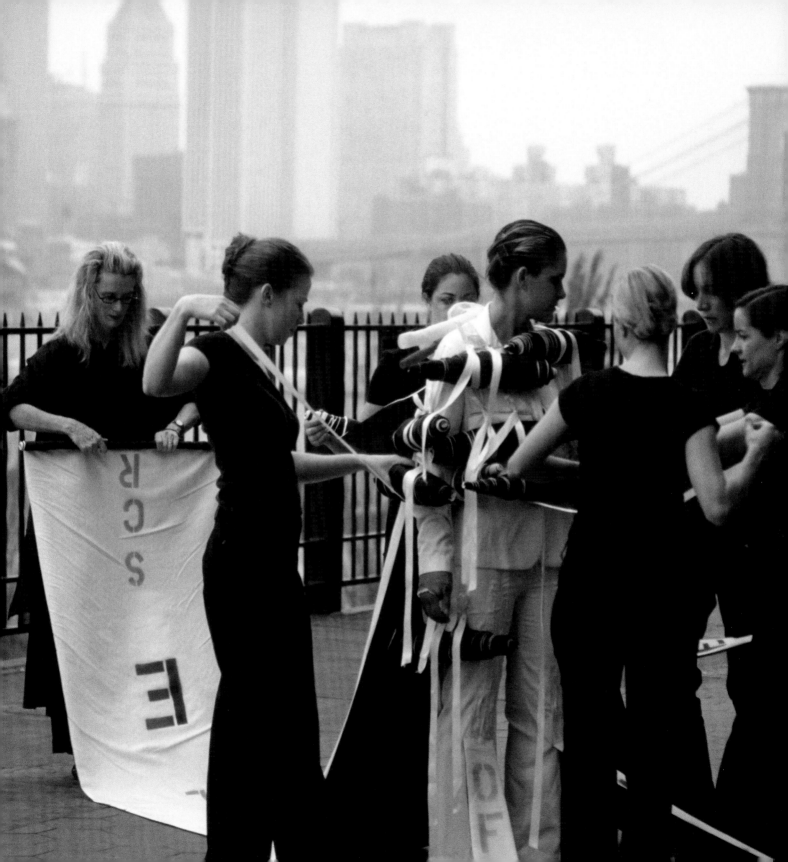

horRible Words

Dug Lad to be dead RaLph

...ys Watching Little Shit friends Watch Little SHit

MB to the crown of the CHeRRy tree

Evil Living Murder woe Witch king suicide teA
war

...y parts flood catastrophe Cataclysm FiRe

...ne caRNaGe Bloodshed slash Gash

attack your own insides with rage

spit / Spue — No Evil Wants his goood

shriLlness writhing maggots the DiN of infinite Pain

You stay Away cosmic hole sucking

inc'y Tumult confusion discord Chaos Helvo

feaR envy despair Guilt shame perturbatio

...igh burst with sucked and gutted offal

...you asshole shithRain asshole

...le knowledge like a big NeRVe Growing shitheA

...y teeth clenched and my tongue pressed

...VE Roof of my mouth I hear Dow

...ined and CRushed Mind with Mi

ACKNOWLEDGEMENTS

The success of this project goes far beyond the efforts of the two collaborating curators who conceived and managed the exhibition and this publication. In addition to a team consisting of McNay staff, creative collaborators, and outside contractors, success also results from the close and invaluable participation of artist Lesley Dill. From the project's inception Dill offered complete access to her studio and archives, making available material that had not been seen by the public before. To the artist, we owe the utmost gratitude.

The work first began with the assistance of Althea Ruoppo, former Semmes Foundation Intern in Museum Studies at the McNay. Althea's efforts continued with the aid of Jacqueline Edwards, Curatorial Assistant, and Genevieve Hulley, current Semmes Intern. Other McNay staff who contributed greatly include Heather Lammers, Collections Manager & Exhibitions Coordinator, and Rebecca Dankert, Associate Registrar for Exhibitions. Rebecca worked closely with the curators on the numerous exhibition and installation details. Finally, Ruben Luna, Chief Preparator, and his talented team worked to achieve the striking installation in the McNay's galleries, and Gary Wise, Manager of Multimedia & Production Services, provided technical assistance with the films and videos of Dill's performances that animate the performance garments on view.

This book, which documents all of Lesley Dill's performances to date, was thoughtfully edited by Diana Lyn Roberts, with a dynamic design and careful production provided by Jessica Haynes of Soleil Adverting, Inc.

The accompanying performance at the McNay of Dill's most recent effort, *Drunk with the Starry Void*, includes the creative input of her collaborators Pamela Ordoñez and Laura Oxendine. Filmmaker Ed Robbins is responsible for creating engaging films of several of Dill's performance works, and his efforts are equally visionary. Other individuals who deserve recognition are George Adams, George Adams Gallery, New York; and Arthur Roger, Arthur Roger Gallery, New Orleans, Louisiana.

As with all endeavors of this type, the success of the project is also dependent on the generous funds provided by donors—here, our thanks go to the Alturas Foundation, Mitchem Partners, and The Tobin Theatre Arts Fund, all based in San Antonio, Texas. Without forward-thinking supporters such as these three, significant projects—including *Lesley Dill: Performance as Art*—cannot be realized.

Lesley Dill thanks in particular her assistants Flavia D'Urso, Natalie Lerner, and Sara Pfau, as well as her mother, Nancy Dill, who is still active as a theatre director herself.

Finally, the curators are most appreciative to William J. Chiego for his encouragement and support of this project, without which our vision could not be realized, and this important aspect of Lesley Dill's work would remain, to a degree, unknown.

— RENÉ PAUL BARILLEAUX

JODY BLAKE

INTRODUCTION

*L*esley Dill: Performance as Art is the first complete survey of the artist's more than twenty-year career creating live performances, an aspect of her artistic practice that she began in 1993. Known primarily for works that are hybrids of sculpture, drawing, photography, printmaking, and installation, Dill's performances animate these static forms and unfold over time. Based in language—both written and spoken—Dill's art incorporates text as a primary component.

This publication accompanies an exhibition of the same title organized by and presented at the McNay Art Museum in 2015. Initially conceived as a catalogue for the exhibition, this book expands the material presented in the museum's galleries to include documentation on each of the artist's performances to date. The following interview with Lesley Dill allows her to speak directly and specifically about sources of inspiration, connections between her diverse creations, and the nature of collaboration. Numerous images connect Dill's performance works with her static images and objects. Following the interview is an equally well-illustrated descriptive catalogue of each performance, also in the artist's words, which chronicles the evolution of this particular body of work.

It is especially fitting that the McNay organize this exhibition and publication. The museum's renowned Tobin Collection of Theatre Arts includes spectacular examples by twentieth-century artists who also investigated the integration of visual and performing arts. Included in this book is an essay by the Tobin Collection's curator, Jody Blake, in which she discusses the art of three luminaries of the period. Blake's essay ties Dill's work to traditions that reach back over a century, traditions that merge modern painting and sculpture with visionary theatre and avant-garde fashion.

More than any of her contemporaries, Lesley Dill's practice spans an array of materials, techniques, and approaches that originate in a single source: language. Whether static or time-based, hung on a wall or worn by a performer, permanent or ephemeral, Dill's art unfolds and even unfurls, speaking a language that is both personal and universal.

—RENÉ PAUL BARILLEAUX

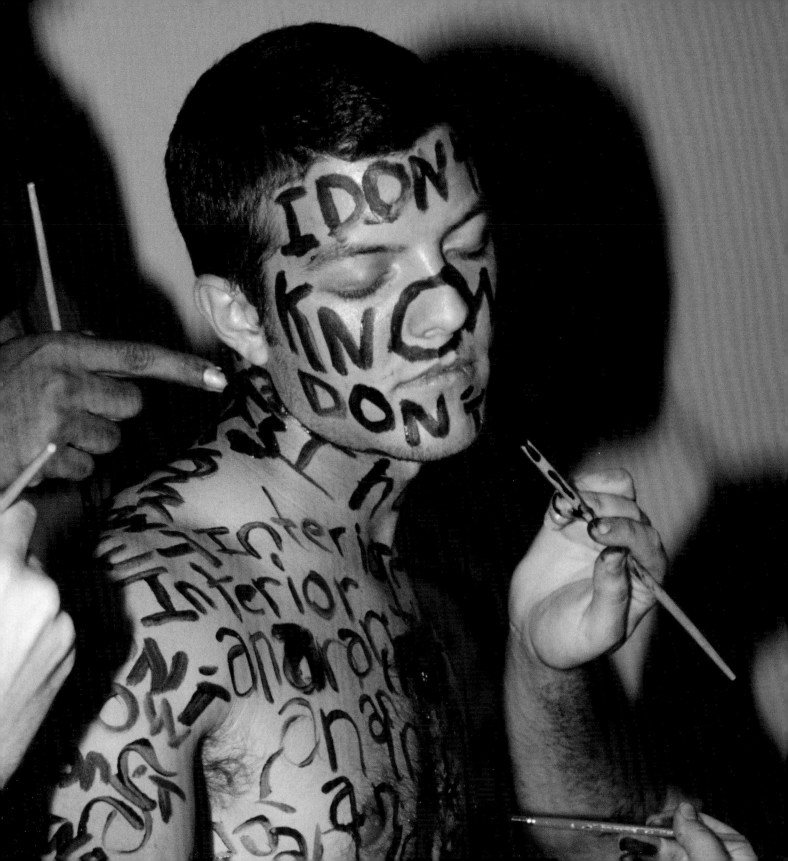

Interview with Lesley Dill

Interview with Lesley Dill

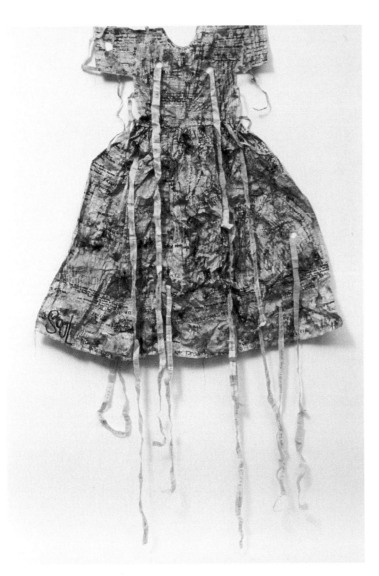

RENÉ PAUL BARILLEAUX: *Lesley, you've been doing performance work for over two decades now—how did you get involved in making performances?*

LESLEY DILL: I got involved in performance through thinking of the act of reading. In 1993 I was invited by freelance curator Robin Kahn at the Guggenheim Museum SoHo, and also at my then-gallery Gracie Mansion, to do some kind of event that involved the poetry of Emily Dickinson.

At that time I was obsessively involved with her poetry, and only her poetry. I thought about giving a simple reading, but that didn't seem enough. I thought, hey, why don't I make a dress, and make one out of paper as it represents the costumed skin of the female body, and cut little holes from which I then pull out streamers of language from Dickinson's poem, "The Soul Has Bandaged Moments." I thought I would still do the reading out loud myself, of the poem, but I would need four performers to gently pull the word ribbons out of the dress. So then "I" became a "we" and we performed *Paper Speaking Dress* at the SoHo Guggenheim in November of 1993, and again in the spring of 1994 at The Kitchen, the New York City performance space.

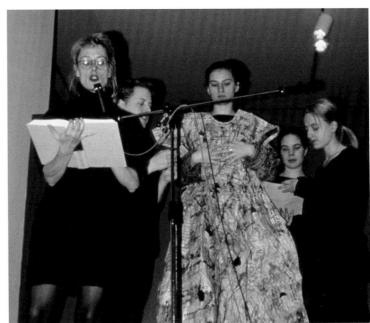

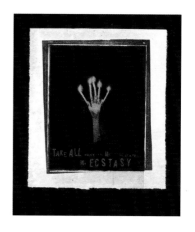

RENÉ: *What is it about Dickinson's poetry that made you obsessed?*

LESLEY: I had never liked poetry that much. I was too speedy a reader then, and would be down at the bottom of the page before the words had a chance to sink in. I really love the density of prose. So, when my mother sent me a book of Emily Dickinson's poems for my birthday one year, I opened the book with little expectation of impact. Little did I know: in turning the pages and sliding my eyes over the words, suddenly my sight would pause and up into them would jump a phrase.

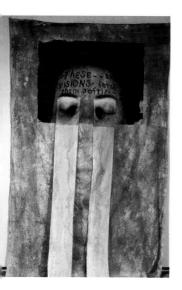
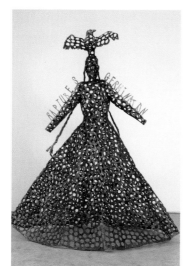
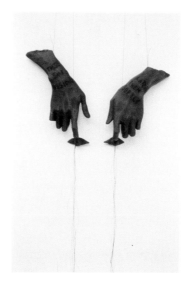
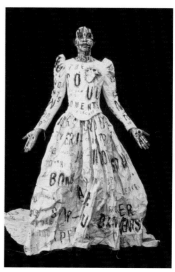

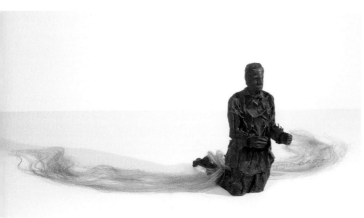

These words had wings and jumped down my throat like electrical blue hummingbirds. I actually saw the words as blue light—really, it's true. And in that place inside me images for art making would be born as a result of this word-jump process. I felt I had found a magic book that was my private farm for sowing and harvesting art, art as connected to language. Dickinson's poetry became my home.

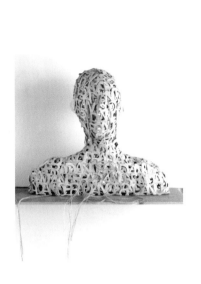
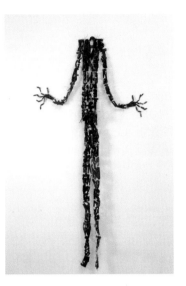
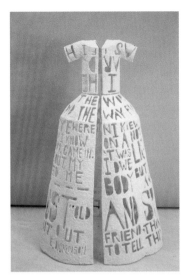
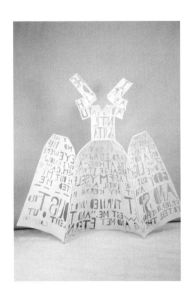

RENÉ: *So once you connected with Dickinson's words, how did you use the written words to make objects? What kinds of things did you make?*

LESLEY: Well, at first, I was still in that swoony place of reading Dickinson and fully formed images rising up. But really, I was full of unarticulated meaning. My internal mind-theatre-psyche had meaning waiting to happen, like actors in the wings. It was the words that shocked me into an imagistic event. It was the connection with phrases, the words like fishhooks that lifted up an idea—plus an accompanying "make me, make me now" urgency. For example, with the Emily Dickinson language "Take All Away from Me but Leave me Ecstasy," I made two pieces. One is a kneeling bronze figure with orange dyed horsehair emitting from and flowing out of the back of her legs, with another Dickinson phrase, "A Wounded Deer Leaps Highest," on her torso in addition to the word "Ecstasy." The other piece is a print from a photograph I took with my friend Jen having lit candles wired to her fingers. In both pieces there is a feeling of flood or flame—of heat being held, and then released. This poem fragment is also the finale song in the opera *Divide Light*. It is generative for me and will be used again.

Regarding "These Saw Visions—Latch Them Softly," first there was the photo and the softness of the image and language in relation to fabric. And then, I wanted this soft phrase to be in conjunction with a more obdurate material: bronze. There is also a similar expansion and compression with this text as with the "Ecstasy" one. "The eyes are awake and alive,…so we must close them gently." Even as I talk about this now, ideas form.

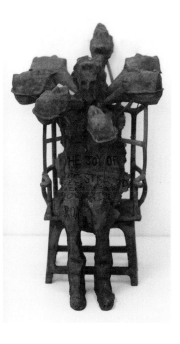
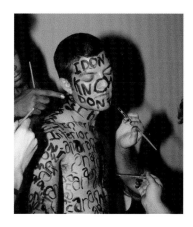
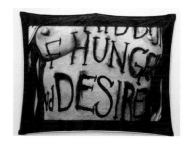
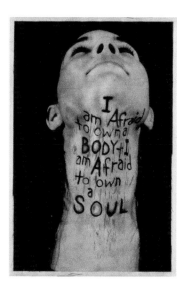
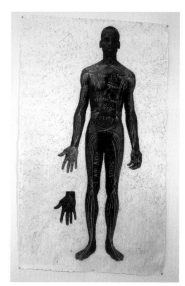
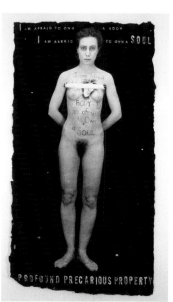

RENÉ: *Then it seems that moving from using text—especially Dickinson's writings—in static works of art, to incorporating text in performance, was a rather natural evolution. But you didn't use text only as spoken word, like in a traditional play, you also made the text physical, visual? Can you talk about how you think about text and language in terms of your performance work?*

LESLEY: I think my confidence in moving into performance started in the studio when I was doing photo shoots for my photographic work in the nineties. I lived in New Delhi from 1990 to 1992. My Indian women friends would stain designs of henna on my hands and feet. When I came back to New York I thought, oh! This is similar to a kind of temporary tattooing. I could paint words on people, as if the words we hold inside our body seep out from the inside to the outside.

I started organizing photo shoots of models with text painted on their bodies. I thought of each person carrying the painted words on them as momentary sculptures. In this way I began to organize small groups of people for the camera. This early choreography for the photo shoots was my start in directing.

RENÉ: *So, making performances was not something you planned out, the performances just evolved?*

LESLEY: Yes. The performances just emerged and grew out of an untended garden. An idea would pop up. Or someone would invite me to do something, and I would say yes.

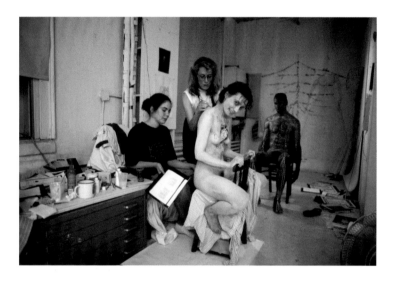

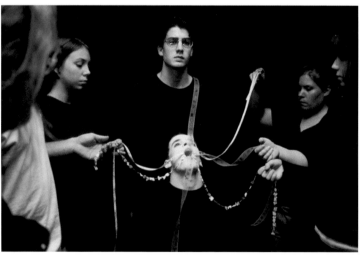

RENÉ: *Got it.*

LESLEY: Here is my secret ingredient. My mother was an actress and director before she married, and continued to be so all through her life to this day, in her independent living place. Consequently, I grew up in a house where a play was always either being directed or acted in. My first year in college at Skidmore I was a theatre major. I performed in a number of wild plays. One was a version of *Dionysus in 69* where we chorus gals were naked from the waist up, painted with silver body paint, and shrieking our lines while positioned in the audience. Well, it was too much for this introvert. So, I hopped off that horse and majored in English literature.

RENÉ: *But that took you away from performance.*

LESLEY: Yes, but eventually, bit by bit, I began to experience the different components of performance. I learned how to direct through photography. Everything was non-digital and in the moment. I worked with film and created all the imagery live in the studio, never through computer editing. And thus the words were literally made flesh by being painted on bodies. Around the same time or a little after I began making paper clothing sculptures for the gallery art space as well as costumes for the theater space.

RENÉ: *Interesting how you separate the two, the gallery space and the theatre space.*

LESLEY: Well, for me at that time, that was the art world I walked into. You'd make a sculpture, a photograph, a print, and then it would go out the door to a museum or gallery space. That was the traditional avenue of communication from the studio to the public.

The engagement with performance happened in my mind, and in real life, in a totally separate place. At the start I really had to allow the performance ideas and desires to hatch in a different mental nursery than my art mind. There wasn't much permission out there to be a committed object-based visual artist and a performance-based one. In fact, I even had a gallerist forbid me to proceed with work in performance.

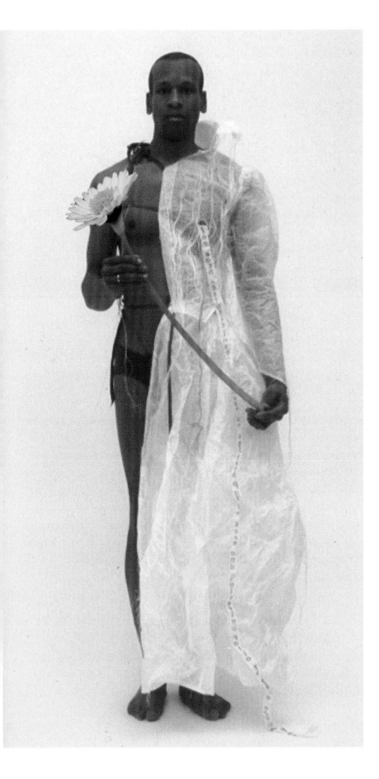

RENÉ: *Clearly that didn't stop you! But let's dig a bit deeper into your use of text in the performance work for a moment.*

LESLEY: Each of my costumes is a performative persona, a character that one "reads." They are presented as spectacles of reading, as they are unfurled, unrolled, or scrolled out. How do we see, how do we think, how do we listen to language? When I lived in India, I became immersed in the unknown (to me) language of Hindi. This allowed me—forced me— to develop a relationship with the sound and the physical appearance of language, a form beyond—behind—the actual meaning of the text. I loved the mystery of being surrounded by a language I couldn't read or understand.

With its recognizable meaning removed, the aural experience of Hindi words and the equally indecipherable twisting of written Hindi script became a melodic and visual unintelligibility that would later influence the costumes, the music, and also the projected animations of my performance pieces.

For me, everything in my work—from performance to prints and photos to sculptures—happens because of the impact of the word. It is the registering of this impact that makes me want to move my work out of my mind and into the world. Whether austere, luminous, murderous, catastrophic, gentle, or ruthless, all these words are causative to or reflective of the states of being they describe. I want the audience to feel these words, both visually and melodically.

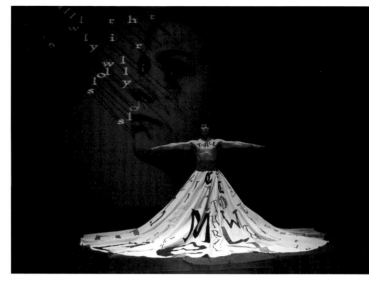

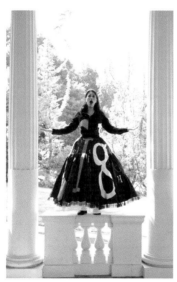

RENÉ: *Okay, so, let's fast-forward a bit. How has the performance work evolved over these twenty plus years? Do you see it as having moved away from your early motivations into developing more complicated theatre pieces, maybe straddling the worlds of the art gallery and a more traditional theatre space?*

LESLEY: My work in performance has jumped hugely in the last twenty-plus years. But let me go right to a thought I am thinking these days, which is that all my work is performance based. I need a big-winged category and perhaps this approaches it. I am actually very shy as a person. Inward. I read a lot. But I think I have a "Theatre of the Interior Mind" inside me. Even my teeniest, tiniest sculpture feels to me as if it is entering into the world stage, whether it be a person's living room, a gallery, or a museum. And the audience is the audience, be it one person or more.

And because of doing my opera, *Divide Light*, I now want my work to have clarity, to reach the back rows as well as the front of a space. In 2008 I conceived and produced *Divide Light*, which combined the language of Emily Dickinson with my belief, derived from my experience in India, in the melodic importance of language.

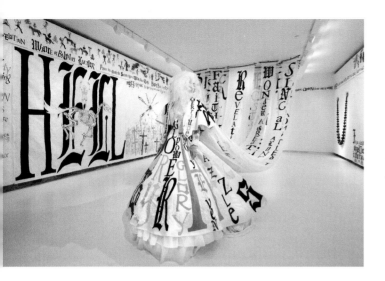

RENÉ: *How so?*

LESLEY: In the costumes, as well as in the moving imagery and text that was projected on the backdrop scrim, I wanted words to be overt, to be readable. My work consequently has culminated in a less introverted reading of words for the audience. This is how I see words inside my mind: big, with impact. I learned to direct my opera singers to sing face forward, with their throat up, not holding the sound too deep in chest or throat, but to release it directly into the audience. I find I now want language to be intense and in front of my inner mind. I desire a more trumpeted clarity of linguistic outreach to the art—and performance—going public. The words are dark against light, not hidden but revealed, definite, declared.

RENÉ: *How has all of this influenced your other work in the studio? Most visual artists don't see their work in a theatrical way— most don't see a connection between a gallery presentation and a theatrical presentation in the way you do.*

LESLEY: As a direct result of working on the opera, I have since done two installation projects. The first was at Arthur Roger Gallery in New Orleans in 2010 and was called *Heaven Heaven Heaven Hell Hell Hell: Encountering Sister Gertrude Morgan and Revelation*. The second exhibition was called *Faith & the Devil*. It is now owned by the Weatherspoon Art Museum in North Carolina and is currently touring.

While I was making *Faith & the Devil* I took language from Milton's *Paradise Lost*, Dante's *Inferno*, Pablo Neruda, Tom Sleigh, Emily Dickinson, Salvador Espriu, and ancient Buddhist texts. I formulated—interwove—the words around themes such as the amorality of animals eating animals, to the immorality of evil murder and dismemberment by humans, the lusty enjoyment of words and sensuality, and counterbalanced by the ideas of forgiveness, thoughtfulness, joy and ecstasy.

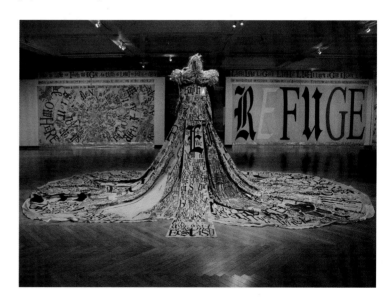

It seemed suddenly, one day, as if these "scripts" for the large drawings I was making for *Faith & the Devil* were actually a libretto.

So, what to do? After having worked for three years with over 80 people on *Divide Light*, I now wanted to travel more lightly. I thought, oh, I wonder can I find a woman, a woman with not an operatic voice, without too much of a self-consciously "sung" voice, and one who could work with me, or I could work with her, in composing? And I found such a woman in Pamela Ordoñez. Her gritty, former rock-singer voice and mind were perfect for this edgy lyrical language I was using for *Faith & the Devil*.

RENÉ: *So what happened next, having found the right collaborator?*

LESLEY: Pamela and I set the above texts to music. We did a workshop performance in New York in 2012, surrounded by the art works of *Faith & the Devil*. Pamela said afterwards, "wouldn't it be great if we could animate these drawings and project them huge behind me?" We raised money from donors and a Hatchfund outreach, and we hired Laura Oxendine, who was the motion graphics animator for *Divide Light*. It has been a fabulous three-way collaboration. We are going to premiere our project, now called *Drunk with the Starry Void*, at the McNay Art Museum on July 9, 2015.

Can I take this conversation in a slightly different direction, René?

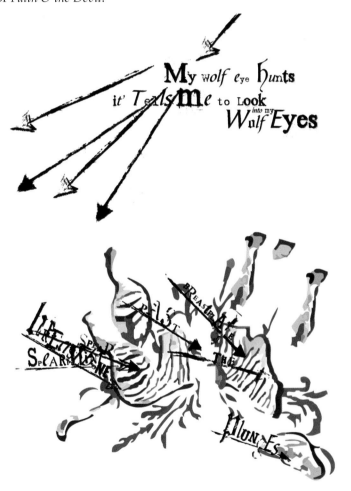

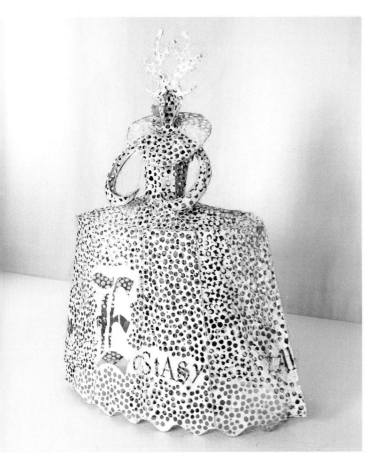

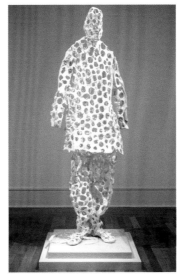

RENÉ: *Of course, what direction?*

LESLEY: Lucky events. It is often lucky events that mark the stepping-stones to growth and expansion.

RENÉ: *How so?*

LESLEY: In 2000 and 2001, in conjunction with the project *Tongues on Fire: Visions and Ecstasy* in Winston-Salem, North Carolina, I had the good fortune to work with the Spiritual Choir of the Emmanuel Baptist Church.

The elders of the church sing in a Gullah-based long-form style. Singing *a cappella* in the vitality of call-and-response, they sing the notes long, slow, and antiphonal. I could feel the pores of my entire body open up as their sound flowed over and through me.

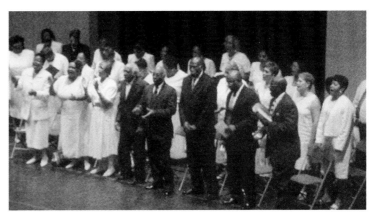

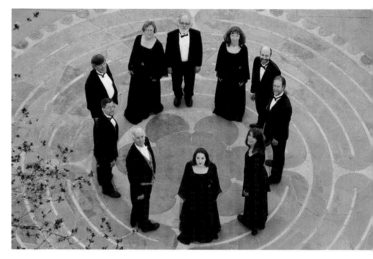

A few years later, I did a project in Boulder, Colorado and met Tom Morgan, the director of the Ars Nova Singers, specializing in the *a cappella* music of the Renaissance and of the twentieth and twenty-first centuries. We worked together for seven years co-composing a CD of music called *I Heard a Voice*, and performed it in Vancouver, Canada as well as Boulder, Colorado. The performance costume *I Dismantle* was made for the Canadian performance. We also used the Ars Nova sound recording for the short film by Christine Redfern, *I Dismantle*. Tom and I worked closely together developing the concept and preliminary music for the opera *Divide Light*.

Then, meeting composer Richard Marriott was very lucky. He and I became friends while working on the final music for *Divide Light*, which he worked on and finished under great time pressure. I am so lucky to have worked with these two extraordinary composers and musicians.

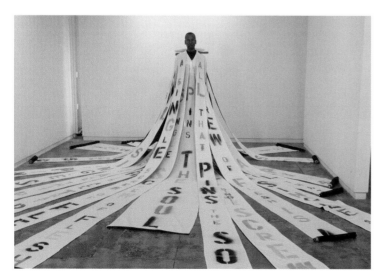

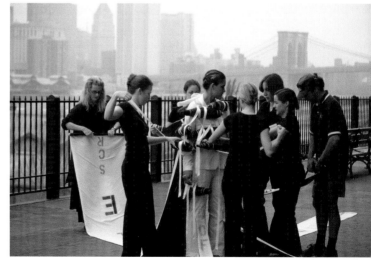

Ed Robbins, my husband, is the filmmaker who turns the performances into films and video. He made *Paris Speaking Dress*, *Sometimes I Feel Skinless*, the opera *Divide Light*, and *We are Animals of Language*, a film about me and my work. I want to thank him for his generosity and his time and his talent over the years.

In May 2014 I was invited to work with the exquisite Ernesto Pujol on one of his performances, this one at the Noguchi Museum and called *Labor of Love*. In silence we did hours of drawing, working, and moving in homage to Noguchi and his works at the museum.

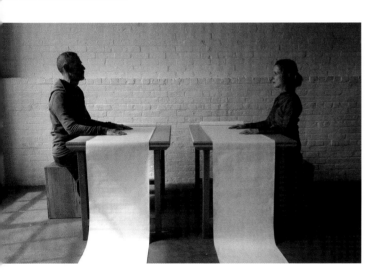

RENÉ: *Those experiences are indeed both lucky and rare!*

LESLEY: Now, I am working with Pamela Ordoñez on the last song of our current musical project, *Drunk with the Starry Void*, which I mentioned earlier. And Laura Oxendine, our motion graphics animator, and I are working on the song, *Blind Desire*. We are looking forward to performing the full premiere of *Drunk with the Starry Void* at the McNay this summer.

RENÉ: *Lesley, I want to thank you for making so many connections in your work, and especially for the great insight you've provided for your audience. I suspect you had no idea where this performance journey would take you when you started that first piece back in 1993!*

Performances, 1993-2015

A Single Screw was an informal performance at Rosa Esman Gallery in 1993, in which a man in top hat wears a paper dress inked with poetry. The dress is made with ink on tea-stained paper and thread. The text is a fragment from Poem #263, "A Single Screw of Flesh is All That Pins the Soul" by Emily Dickinson. The dress was made for a friend to wear at the opening reception of my exhibition at Rosa Esman Gallery.

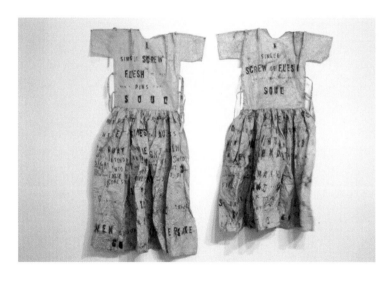

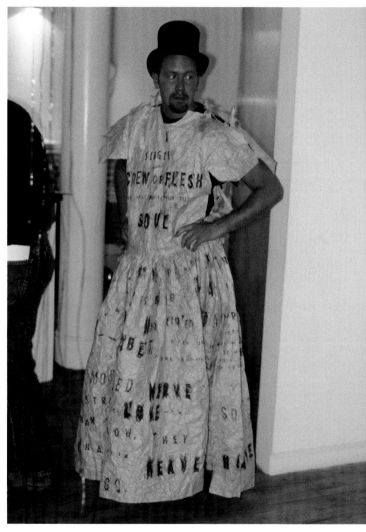

A Single Screw (Man in Top Hat)
Performed 1993 at Rosa Esman Gallery, New York

*P*aper Speaking *Dress* is a performance of language and materials. During the performance, I read aloud Poem #512, "The Soul Has Bandaged Moments" by Emily Dickinson, while a performer is wearing a dress of paper inked with the full text of the poem. Simultaneously, other performers are pulling and untying ribbons from the dress.

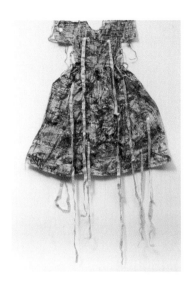

Paper Speaking Dress

Curated by Robin Kahn

Performed November 2, 1993 at Guggenheim Museum SoHo, New York

Performed January 1994 at Gracie Mansion's private residence, New York

Performed April 2, 1994 at The Kitchen, New York

Woman in Dress: Trista Kelver

Other Performers: Sue de Beer, Lesley Dill, Erin Lochran, and Allison Smith

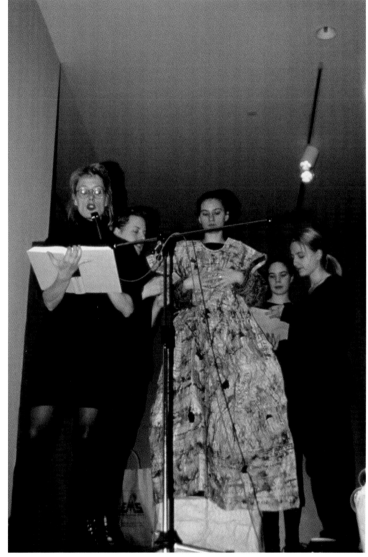

The *Dada Poem Wedding Dress* was made for the Dada Ball held in New York on October 12th, 1994 at Webster Hall. The event was a benefit for Visual AIDS and Housing Works. In this performance I wanted to talk about our era of AIDS and also the theme of the Dada Ball by using the metaphor of a woman wearing a dress. The idea was inspired by Marcel Duchamp's *The Bride Stripped Bare by Her Bachelors, Even*. The dress is a brown paper dress painted white and stamped with the words of the Emily Dickinson poem, "The Soul Has Bandaged Moments." I chose a virginal white dress as a reminder of the many women who are HIV positive, and as a symbol of the incredible loss of innocence that awareness of early mortality has brought us. In many ways, though on a more subtle parallel level, the wedding event is one of loss of single selfness, and potential gain of a doubly lived life. At the time of the ceremony itself, the bride and family are in a moment of experiencing loss of an unknown future. The ceremony and accompanying celebrations are nevertheless joyous in anticipation of expanded family and uniting community. The champagne comes with the uncertainty and hope.

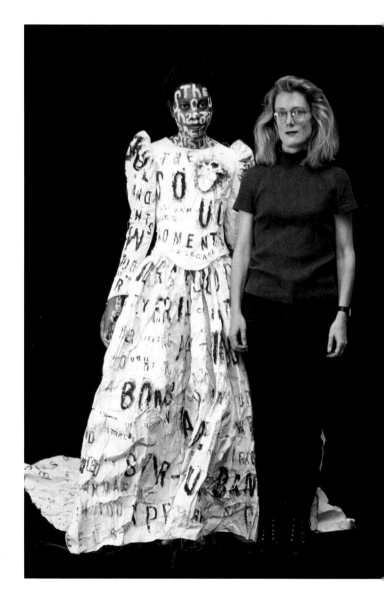

Dada Poem Wedding Dress

Performed October 12, 1994 at the Dada Ball, Webster Hall, New York

A Benefit for Visual AIDS and Housing Works

Woman in Dress: Auriea Harvey

Other Performers: Sue DeBeer, Lesley Dill, Erin Lochran, and Allison Smith

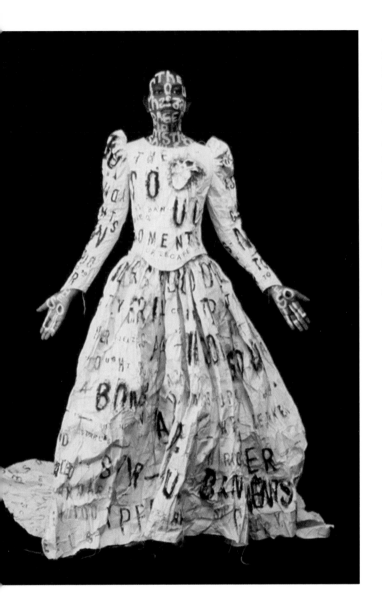

As the words of the poem were recited, four of us began ripping the dress apart word by word. The intention was inspired by Duchamp–the bride stripped bare. But by having women doing this instead of "bachelors" I hoped to include a feeling of tending, and the care of grooming that women-to-women can give. As we tore the dress, it no longer represented an aloof beauty, protected by this skin/dress/bandage of words. It was ripped to shreds, paralleling our fragile mortality as well as the unending violence against women. But the performer, now dress-less, is painted with the same words of the poem on her nude body. With silence and care I went to her and with my mouth drew out a long ribbon from her mouth, both of us mutely testifying to the survival and strength of the spirit.

Afterwards, I sewed the dress back together again.

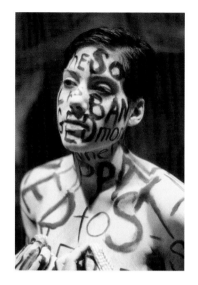 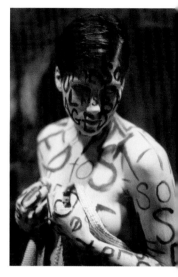

In *Sometimes I Feel Skinless*, a woman wearing a dress covered in the text of Emily Dickinson's Poem #512, "The Soul Has Bandaged Moments" has the dress torn off by other performers revealing her nude body covered in paint and language, same text as the dress. While this is going on, four people are reading the poem aloud. When the dress is completely ripped off and the woman is standing nude with her painted words, Lesley Dill slowly approaches her from the back of the room and kisses her on the mouth, taking the end of a ribbon that has been in the performer's mouth and, walking backwards, ends the performance. This work was performed at George Adams Gallery in New York.

There is a 14-minute DVD of the performance.

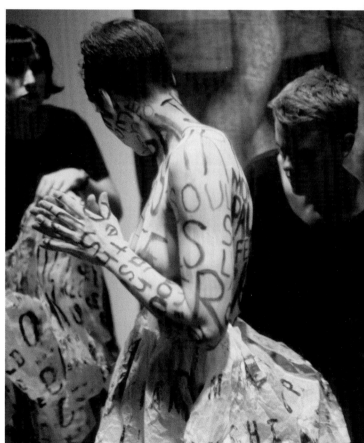

Sometimes I Feel Skinless

Performed October 12, 1995 at George Adams Gallery, New York

Woman in Dress: Kimberly Richter

Other Performers: Lesley Dill, Moira Driscoll, Kat Kinsman, Coco McPherson, Annie Murdock, David Pence, and Jane Smith

Video by Ed Robbins

Poem Dress for a Hermaphrodite was a piece for Pulp Fashion, an art and fashion show at Dieu Donne in New York. The dress, made of light vellum, has a ribbon with the text from Emily Dickinson's Poem #125, "For Each Ecstatic Instant" running down the length of the dress and onwards to the floor. The dress is worn by Sur Rodney Sur, who has half of his nude body exposed and the other half covered in the dress.

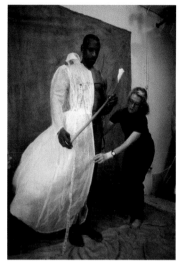

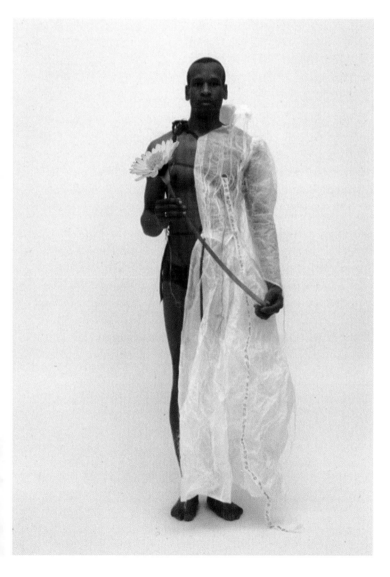

Poem Dress for a Hermaphrodite

Performed December 2, 1995 at Dieu Donne, New York for Pulp Fashion
Performer: Sur Rodney Sur

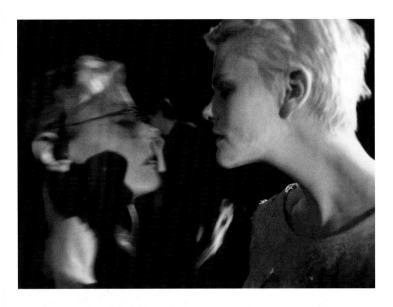

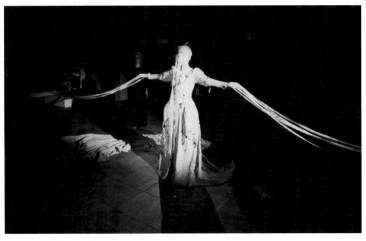

Paris Speaking Dress represents the skin of the body as well as, metaphorically, the various orifices and holes we have in our bodies. It is not just our mouth that speaks. In different ways our eyes, ears, nipples, sexual organs, etc. all emit various essences of the body. They are instruments within a dialogue between the inner and outer world.

The dress, with a 20 foot train, is worn by a performer who also has some of her senses extended outward and some muted or sheathed. Her eyes are veiled by two fabric extensions ("vision catchers") that fall in a long trail downwards, covering her eyes as well as representing visions stretching outwards.

During the course of this ten-minute performance, Lesley Dill and one American plus six French performers slowly and gently remove and reveal elements written over and over with the text of Poem #512, "The Soul Has Bandaged Moments" by the nineteenth century American poet, Emily Dickinson. Additional text is by Dill.

Throughout, there is also a sound element: an original soundscape recorded on audiotape, compiled by Ed Robbins. The accompaniment is a layering of sounds, an interweaving of voices female and male, American and French. We hear them whispering, speaking, keening, singing in unison and alone, layered and altered. They are reciting the same poem as the one written over and over on the dress and ribbons and gloves. As on the dress, the words of the poem are both intelligible and not, exposed and hidden.

There is a 14-minute DVD of the performance.

Paris Speaking Dress

Curated by Bill T. Jones

Performed April 1996 at the Maison des Arts de Creteil, Paris, France

Woman in Dress: Annie Murdock

Other Performers: Cecile Baudau, Natasha Black, Lesley Dill, Arnaud Dutheill, Antoine Ehrhard, Bruno Rosaz, and Paola

Video by Ed Robbins

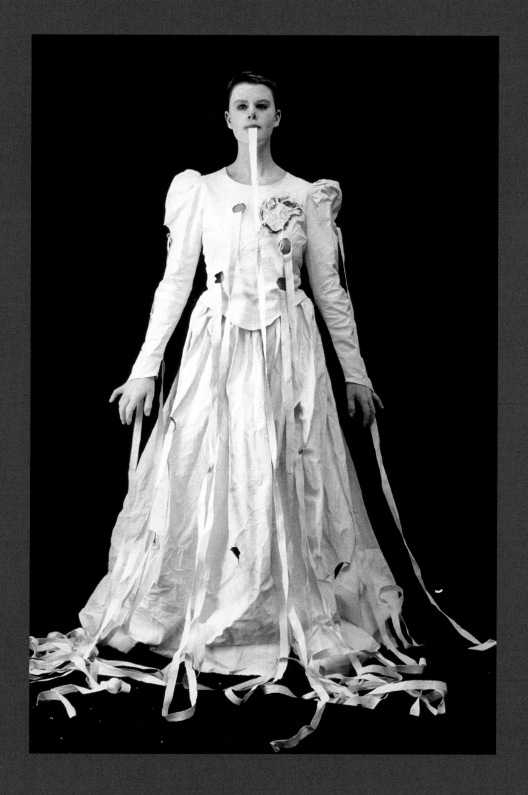

37

In *Worst Case Scenario*, choreographers/dancers Lawrence Goldhuber and Heidi Latsky were among my first collaborators on a work that takes a poignant—and sometimes comic—look at how both the alienation and intimacies of city life have an impact on interpersonal relationships. Commissioned by the Whitney Museum of American Art at Phillip Morris, this piece is the second part of an evening-length work, *I Hate Modern Dance*. *Worst Case Scenario represents* the "Hate" in the title.

There is a 60-minute DVD of the performance.

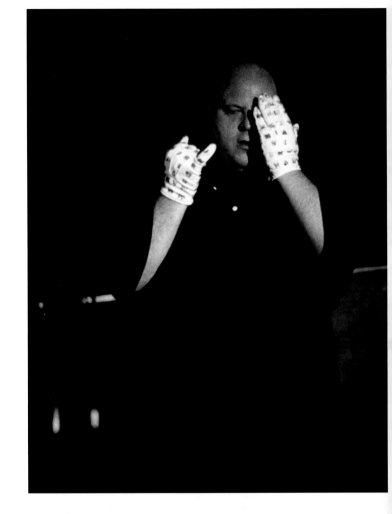

Worst Case Scenario

*Performed June 4, 1998 at Whitney Museum of American Art
at Phillip Morris, New York*

Performed April 22, 1999 at P.S. 122, New York

A collaboration with Lawrence Goldhuber/Heidi Latsky and Lesley Dill

Performers: Lesley Dill, Lawrence Goldhuber, and Heidi Latsky

Video by Ed Robbins

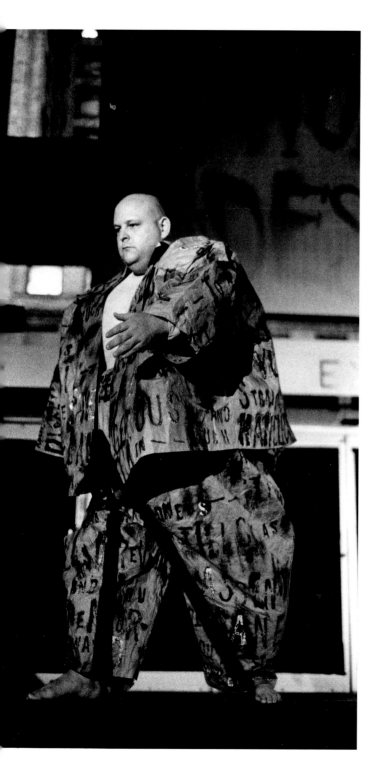
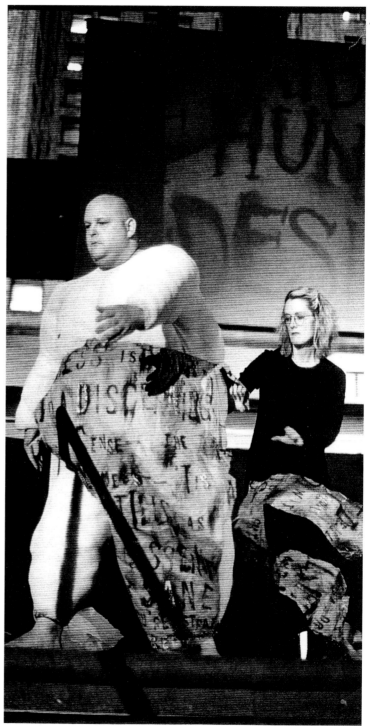

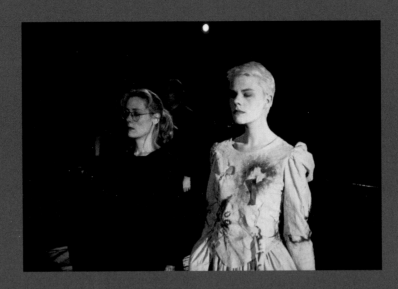

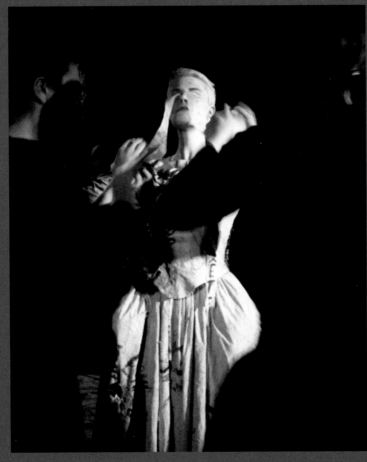

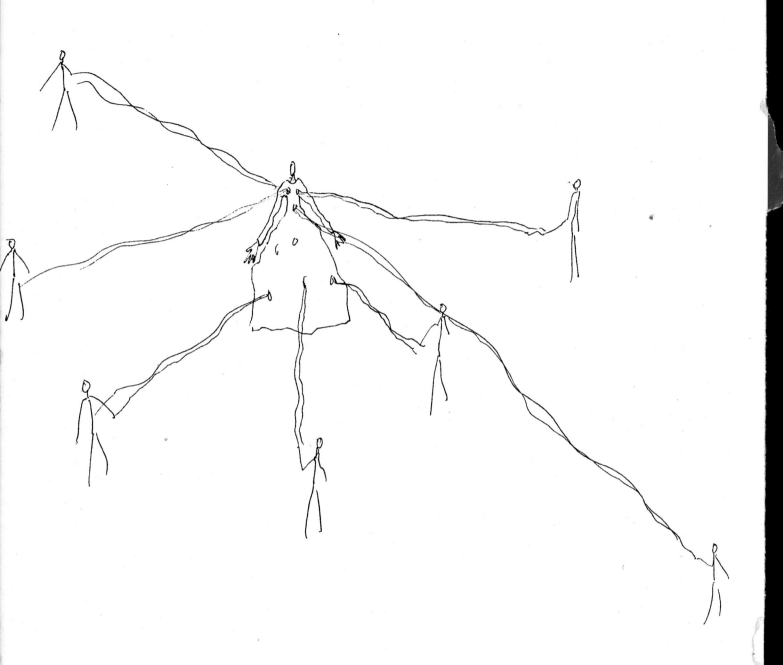

Ribbons slowly pulled from dress

In Tongues on Fire, it was the language of visions—be it in dreams or unusual sensory experiences, spontaneous vocalizations, or uncontrolled bodily movements—that I was interested in investigating in the community of Winston-Salem. I wanted to have people tell me their stories.

I set out with the staff of the Southeastern Center for Contemporary Art to gather stories about the deeply personal, life-changing, often baffling experiences that define a plane of human existence that is frequently ignored or at best misunderstood. We conducted numerous gatherings with community groups, one of which took place in April 2000 at a local women's center with a group of ministers called the Interfaith Partnership for Advocacy and Reconciliation. At this session I asked where I might find a church where people would be willing to talk with me about visionary experiences.

This query led me to the Emmanuel Baptist Church and the Reverend John Mendez, a powerful spiritual leader, activist, and seer. Part Apache, part Yoruba, Mendez is an African-American man of learning and presence who irrevocably altered the group's understanding of Christianity. At Emmanuel Baptist Church, I found a spiritual "home" on Palm Sunday 2000.

Tongues on Fire: Visions and Ecstasy evolved into a multi-tiered project: an exhibition of new works inspired by more than 700 vision statements collected by the artist and museum; a series of large billboards strategically placed on a major North Carolina highway and duplicated in the museum for the exhibition; an opening night Spiritual Sing with the Emmanuel Baptist Church Spiritual Choir; a documentary film by the University of North Carolina School of the Arts chronicling the history of the choir and Dill's involvement with it; and finally, two publications—a catalogue, and an edited, printed collection of the 700 vision statements.

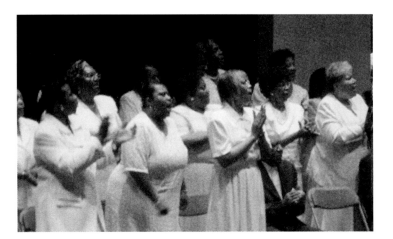

Tongues on Fire: Spiritual Sing

Curated by David J. Brown

Performed May 11, 2001 at Southeastern Center for Contemporary Art, Winston-Salem, North Carolina

Performed by the Spiritual Choir of the Emmanuel Baptist Church
In conjunction with Lesley Dill's project, Tongues on Fire: Visions and Ecstasy

Songs from language collected from the community of Winston-Salem, North Carolina

Video by University of North Carolina School of the Arts School of Filmmaking and Emmanuel Baptist Spiritual Choir

Interviews with a Contemplative Mind was a project designed by me and sponsored by the University of Colorado Art Galleries. The project joined individuals and groups in the Boulder community to explore the possibilities of art as a participatory process. The intention of Interviews with the Contemplative Mind is to insert a pause in the daily rush of life and to create moments of reflection and aesthetic enjoyment via poetry, music, and art.

I worked with classes at the University of Colorado and Naropa University to "collect language" through interviews exploring individual experiences of contemplative awareness. Participants were then invited to extend the language collection process further into the community by setting up interviews with friends, strangers, colleagues, and family. In the fall of 2002, up to 15,000 cards were printed and distributed by students and other participants as small gifts—at grocery stores, shopping malls, bus stations, city parks, and other everyday public venues. One side of each card featured a photographic image created by me in response to experiences of Boulder and the language we collected there. The other side had several lines of "collected language" from the community. Five separate cards were produced for the project. Some of the language was printed in English, some in Spanish, and some cards had a line embossed in Braille.

Tom Morgan, Lesley Dill, and the Ars Nova Singers worked together to create an evening of song from the collected language. They ultimately created a 45-minute compact disk titled I Heard a Voice and performed it again in 2003 in Canada. Tom Morgan and Lesley Dill worked together for seven years.

Interviews with the Contemplative Mind

Curated by Susan Krane

Performed 2002 at University of Colorado Art Galleries, Boulder, Colorado

Music composed by Thomas Edward Morgan and Lesley Dill, in collaboration with the community of Boulder, Colorado

Sung by the Ars Nova Singers

Compact disk produced by Ars Nova

I Heard a Voice was a collaboration with Tom Morgan, Artistic Director of the Ars Nova Singers, to create a new extended musical work for unaccompanied chorus based on the project *Interviews with the Contemplative Mind.* We used "found poetry" collected from the Boulder, Colorado community as inspiration and actual song lyrics. The songs, with intense polyphonic auditory wave, investigate the concepts of: hearing, "I heard a voice"; seeing, "I had a vision"; and speaking, "It is a pilgrimage to say how."

While in Coquitlam all 45 singers from Ars Nova and I took a bus into the city for dinner. To the delight and amazement of the other bus riders, the singers burst into polyphonic sound and sang a song! Then, at the restaurant, it was someone's birthday. When their little cupcake with a candle came out, all of the Ars Nova singers stood up and sang a medieval chorale-style "Happy Birthday." It is these things that are the spontaneous pleasures of working together.

Ars Nova Singers:

Soprano: Sarah Amirani, Susan Casper, Alexa Doebele, Leanne Gyetvai, Julie Poelchau, Karen Ramirez, Lorienne Schwenk, and Cheryl Staats

Alto: Linda Akey, Jan Botwinick, Janet Braccio, Amy French, Mary Jarrett, Melinda Mattingly, Suze Villano, and Rhonda Wallen

Tenor: Jeduthun Hughes, J.R Humbert, Arnie Lehmann, David Nesbitt, Jack Rook, Glenn Short, Louis Warshawsky, and Rick Wheeler

Baritone/Bass: Brant Foote, David Gleason, John Hyde, Michael Lewis, Bruce Stout, Steve Weaver, Don Wilson, and Steve Winograd

I Heard a Voice

Performed 2003 at Evergreen Cultural Centre, Coquitlam, British Columbia, Canada

Music composed by Thomas Edward Morgan and Lesley Dill

Sung by the Ars Nova Singers

Images by Lesley Dill

I Dismantle revolves around a single costume. Constructed out of silk and cotton material, the dress at its widest measures 30 feet in diameter. The performance of *I Dismantle*, produced and filmed by Christine Redfern, took place in Brooklyn, New York, with Manhattan as a backdrop to the actions. Megan Moorehouse performs the work with Ariana Boussard-Reifel, Molly Lloyd, Maggie Odell, and Andrea Ryder. The accompanying music is by composer Tom Morgan and Lesley Dill, sung by the Ars Nova Singers from Boulder, Colorado.

The performer walks in costume, wearing 20 rolled-up scrolls of text. In many ways, this is what we do in life: we carry our language with us all the time. The performer stops. Four women come quietly to her. Slowly, they start to unravel, to dismantle, and to express her language out into the world. They unroll the fabric panels with care and gentleness, as if they are tending her, midwifing her words out. The language on the cloth is from an Emily Dickinson poem. It reads, "A Single Screw of Flesh is all that Pins the Soul." At the end of the work, the text on wide fabric strips radiates out in every direction from the woman in the dress. The *a cappella* music includes murmurs, swells of volume, and an operatic quality. As it rises to a crescendo, two veils—one white and one red—are rolled over the performer's face. She is now the speaking body writ large, and the smaller mouth of the linguistic face can be muted.

There is a 6-minute DVD of the performance.

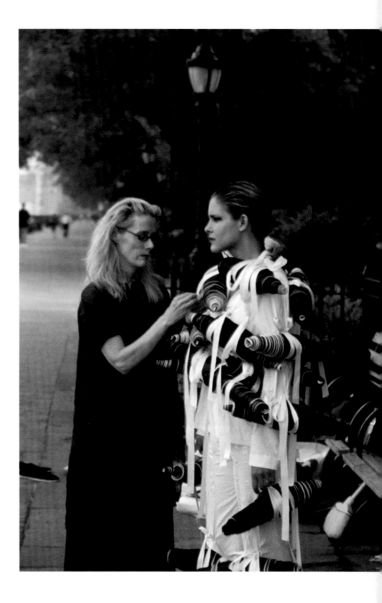

I Dismantle

Performed 2004 on the Brooklyn Promenade, New York

Conceived and directed by Lesley Dill

Woman in Dress: Megan Moorehouse

Other Performers: Ariana Boussard-Reifel, Molly Lloyd, Maggie Odell, and Andrea Ryder

Film by Christine Redfern

44

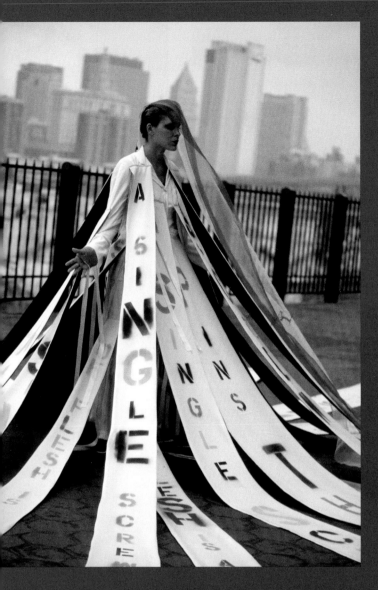
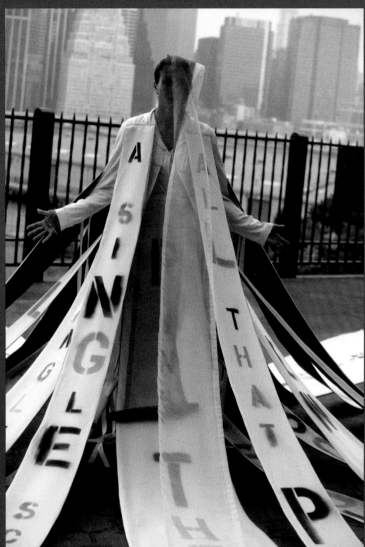

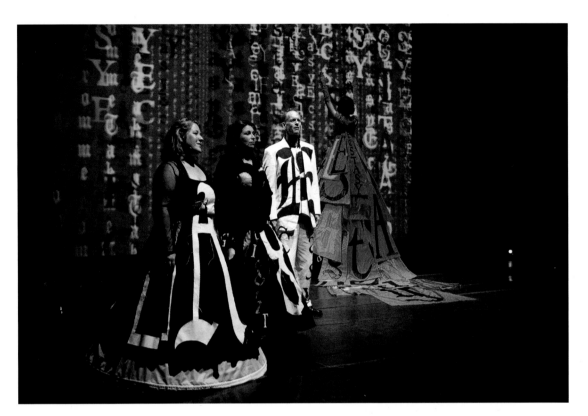

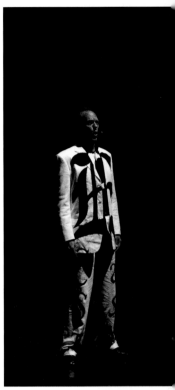

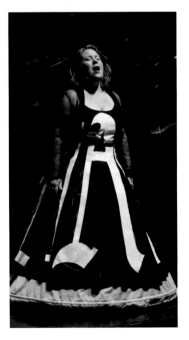

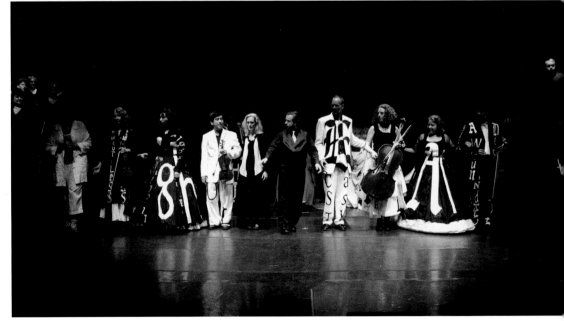

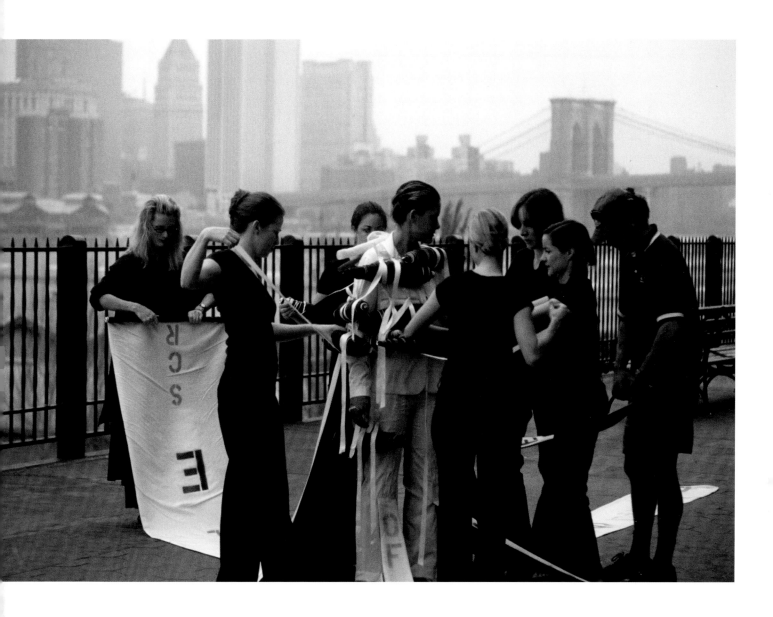

45

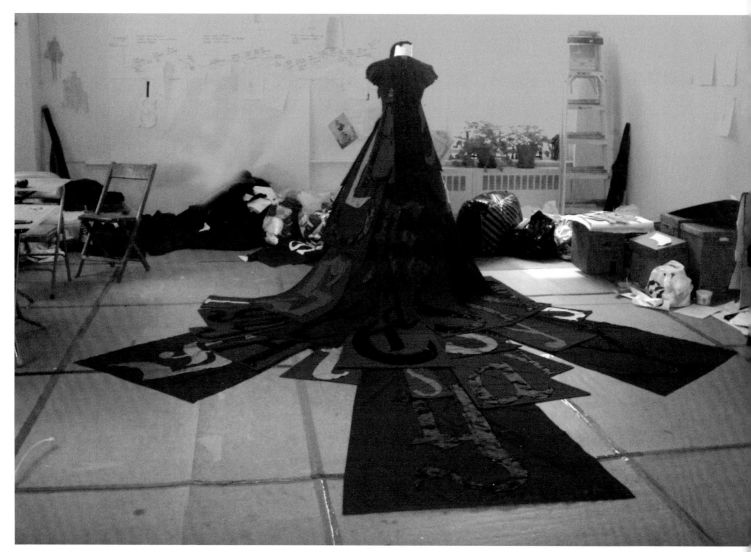

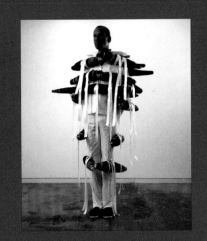

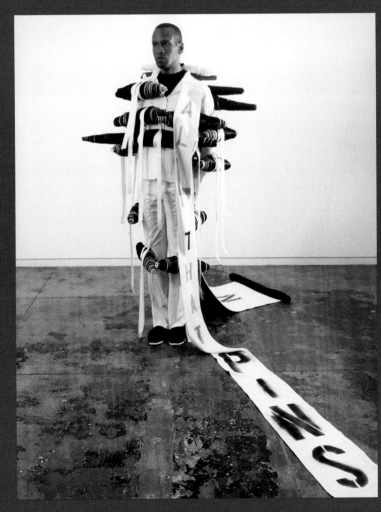

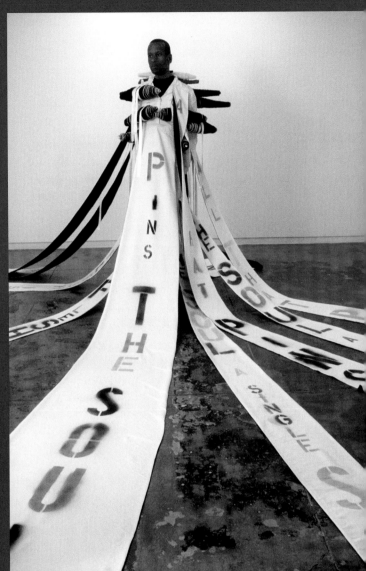

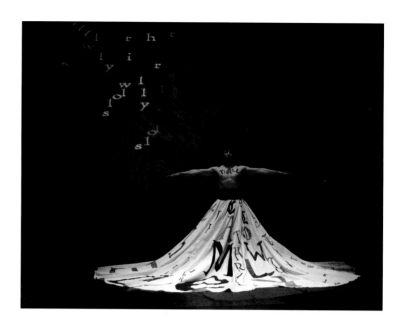

A high mark of my lifelong inspiration from Emily Dickinson's poetry is *Divide Light*, an opera based on the poet's complete works. I conceived the opera, served as artistic director, and collaborated with composer Richard Marriott on the music. I also designed and created all the costumes in the studio. *Divide Light* follows a dramatic and emotional contour, exploring a range of emotions from vulnerability and fear to ecstasy, joy, and exhilaration.

Divide Light premiered August 13, 2008 at the Montalvo Arts Center and featured performances by the Del Sol String Quartet; the 45-voices of The Choral Project; Jennifer Goltz, soprano; Kathleen Moss, mezzo-soprano; and Andrew Eisenmann, baritone. The performers sing Dickinson's words and also wear Dill's ravishing costumes, with the texts scrawled across them. The set is a continuously moving video installation of poems and Dill's evocative black-and-white photographs.

There is an 82-minute DVD of the performance, a 12-minute sample DVD, and an 82-minute soundtrack.

Divide Light was commissioned by Montalvo Arts Center and supported in part by grants from the Rockefeller Foundation Multi Arts Production Fund, The William and Flora Hewlett Foundation, The David and Lucile Packard Foundation, and the National Endowment for the Arts.

Divide Light

Performance premiere August 2008 at Montalvo Arts Center, Saratoga, CA
Conceived and directed by Lesley Dill
Music composed by Richard Marriott
Performed by the Del Sol String Quartet and The Choral Project under the direction of Daniel Hughes
Jennifer Goltz, soprano; Kathleen Moss, mezzo; Andrew Eisenmann, baritone
Soundtrack produced on audio compact disk
Film by Ed Robbins

Divide Light

Film premiere April 2009 at Anthology Film Archives, New York
Conceived and directed by Lesley Dill
Music composed by Richard Marriott
Soundtrack produced on audio compact disk
Film by Ed Robbins

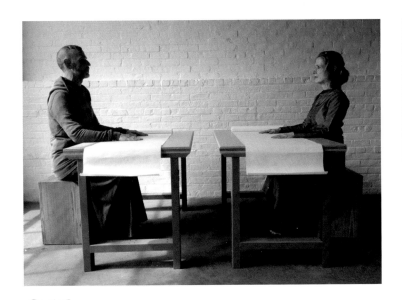
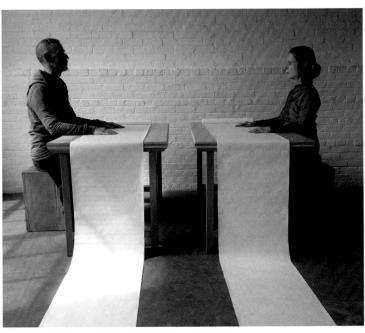

*L*abor of Love was created for the Noguchi Museum by performance artist Ernesto Pujol, working with Lesley Dill. The site-specific performance took place on Saturday, May 3, 2014 from 11:30 a.m. to 5:30 p.m. EST.

Labor of Love is a durational piece that began in the morning, shortly after the opening of the museum, and ended in the late afternoon, shortly before its closing, lasting six hours. The entire performance is done in silence.

The performers enter the gallery together, sit separately at two identical work tables, face each other under garden windows, and draw all day long on unfolding rice paper scrolls. Throughout the six hours, the performers pause, set down their tools, rise and ring Noguchi stone bells, slowly walk in a small circle, switch places, and continue working on each other's white scrolls. The performers engage in spontaneous exchanges, mark-making individually and sequentially.

The work of Isamu Noguchi impresses viewers not only with its master craftsmanship, but also with its love. Anyone who contemplates his legacy can feel the love Noguchi felt for nature, art, and humanity. His works are an invitation to deep presence. Artists Pujol and Dill hoped to experience the Noguchi spirit for one day.

Labor of Love
Performed May 2014 at the Noguchi Museum, Long Island City, New York
Performed by Ernesto Pujol and Lesley Dill

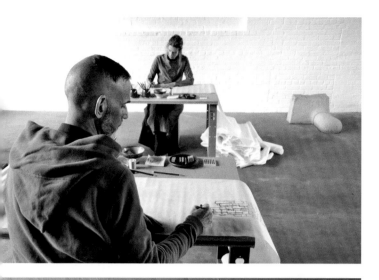

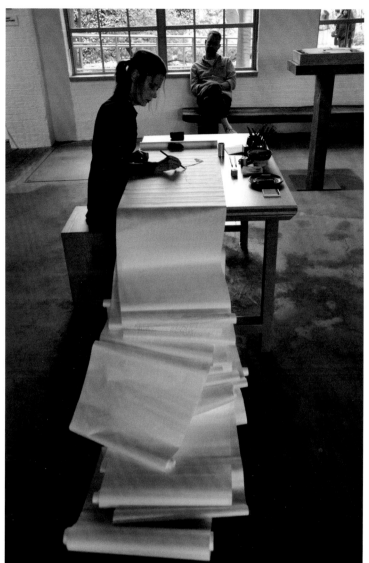

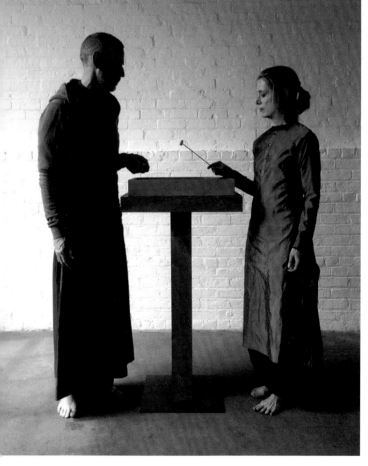

53

*D*runk with the Starry Void was conceived in 2012. I had just finished a large installation of works titled *Faith & the Devil*, owned by the Weatherspoon Art Museum in North Carolina. I collected a large number of writings by authors including Dante, Milton, Neruda, Sleigh, Dickinson, and Espriu for the exhibition. I wanted to continue exploring philosophical conundrums and complexities from Evil to Grace. To this end, I interwove linguistic fragments into large drawings and sculptures, with an emphasis on themes of thoughtfulness, cruelty, lust, forgiveness, and ecstasy.

This language called out to become performative, as a textual vocalization. To create the workshop performance, *Drunk with the Starry Void*, I found vocalist / composer Pamela Ordoñez to work with in setting the texts. For full-scale performance, we added motion graphics animator, Laura Oxendine, who created the animations for *Divide Light*, to face the challenge of animating Dill's big drawings and sculpture imagery. Now, when Ordoñez steps onto the stage to sing, she has a huge moving backdrop of images and text that partner with the lyrics of each song. She will be joined by two singers from the San Antonio community for the performance premiere of *Drunk with the Starry Void* at the McNay Art Museum.

Drunk with the Starry Void

Workshop performance May 2012, George Adams Gallery, New York
Composed and performed by Pamela Ordoñez
Artistic direction by Lesley Dill

Drunk with the Starry Void

Performance premier July 2015, McNay Art Museum, San Antonio, Texas
Composed and performed by Pamela Ordoñez
Motion graphics animation by Laura Oxendine
Artistic direction by Lesley Dill

Drunk with the Starry Void

Songs of thoughtfulness, cruelty, joy, lust, horrible words, radiance and refuge.

Using a text smash of poets - Dante, Milton, Donne, Sleigh, Kafka.

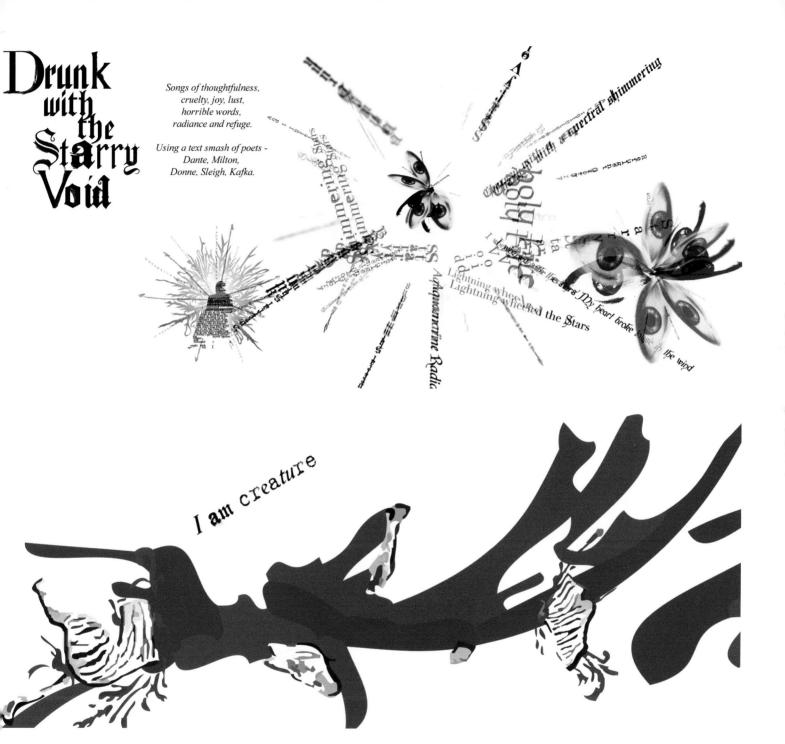

I am creature

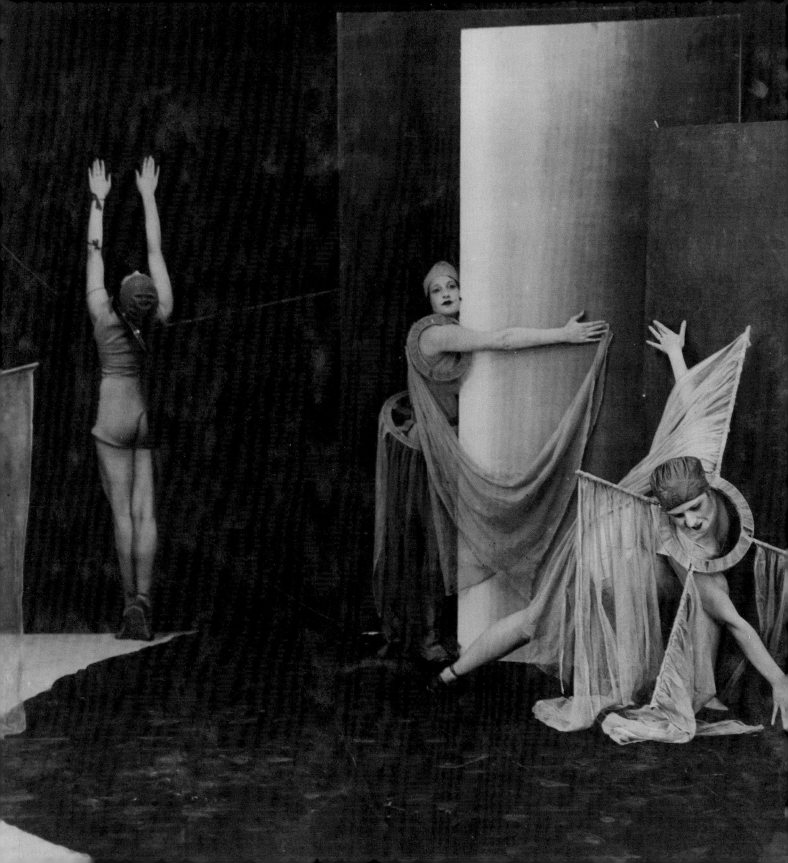

Performing Garments:
Lesley Dill and the Russian Avant-Garde

Lesley Dill is hardly alone among contemporary visual artists in her interest in the body and in language. What sets Dill apart, however, is her focus on the ways in which the body can speak only in performance. Written and spoken words, movement, and music—all are centered on performance garments with their own visual eloquence. The result is poetry, not polemics, often of unutterable beauty. Although Dill occupies a distinctive position today, her work has unexpected historical precedents. In the creative ferment of the 1910s and 1920s, a trio of Russian artists pioneered many of the ideas to which Dill gives unique and decidedly contemporary expression in her own performance art. Most important, these earlier artists designed theatre costumes that—both in conception and in construction—were much more than mere clothes. Like Dill, they explored garments as kinetic sculpture, extending the performer's body, gestures, and utterances into an environment of form, color, light, sound, and movement.

Natalia Gontcharova (1881-1962), Alexandra Exter (1882-1949), and Sonia Delaunay (1885-1979) came of age at an exhilarating time in Russia, where they were born, and in France, which became their adoptive home by choice and by circumstance after the First World War and the Bolshevik Revolution. As young artists in Kiev, Moscow, and St. Petersburg, they forged their work from the succession of modernist styles culminating in French Cubism, Italian Futurism, and Russian Constructivism. Of the generation of "New Women," they were drawn to Paris where they continued to study and teach, exhibit and publish, consolidating their reputations as modernist innovators not only in visual art but also, and perhaps above all, in theatre.

No country had embraced the idea of theatre as a total work of art—fusing painting, sculpture, poetry, music, and dance—more avidly than Russia. Serge Diaghilev's Ballets Russes, which debuted in Paris in 1909, and Alexander Tairov's Kamerny (Chamber) Theatre, founded in Moscow in 1914, exemplified this synthesis of the arts. Gontcharova, Exter, and Delaunay designed their first productions at a time when theorists challenged the proscenium, or picture-frame stage,

rejecting the Renaissance tradition of painterly illusionism. Like their contemporaries, these three Russians sought new approaches to theatre design in the innovations of Cubo-Futurism and Constructivism. Working in different contexts, and with different creative interests, Gontcharova, Exter, and Delaunay nevertheless shared one goal: to integrate costumes and scenery, performers and settings, in a dynamic, three-dimensional stage environment.

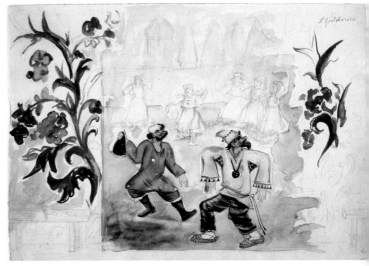

Figure 1

NATALIA GONTCHAROVA: COSTUME AS SCULPTURE

Cubism is a positive phenomenon but it is not altogether a new one, especially as far as Russia is concerned. The Scythians made their stone maidens [Kamennaia baba fertility figures] in this hallowed style. Wonderful painted, wooden dolls are sold at our fairs. These are sculptural works, but in France too it was the Gothic and the African figure sculptures that served as the springboards for Cubist painting.[1] —Natalia Gontcharova

Natalia Gontcharova came to Diaghilev's attention as much with her outspoken pronouncements as with her bold canvases, both of which had earned her the position as leader of the Moscow-based Neo-Primitivist movement along with her artistic and life partner, Mikhail Larionov. Gontcharova's debut production, *Le Coq d'or* (1914) (Figure 1),

a pseudo-folktale in which Russian wood carvings seemed to come to life with all their brilliant color, decorative patterns, and naive charm, more than met expectations. However, from a technical point of view, her costumes (sewn from hand-painted fabric) and scenery (painted on drops and wings) were conventional.

That changed during the First World War, when Diaghilev's company sought safety away from Paris and abandoned its usual production schedule. Inspired by their travels, Gontcharova collaborated with choreographer Léonide Massine to embody movement traditions outside the vocabulary of European classical dance. Their ideas, expressed in Gontcharova's drawings and Massine's notes, represented a radical breakthrough in design as well as choreography. Gontcharova later explained the concept underlying her costumes:

Costume and décor can be related to one another sometimes in a highly complex manner. For example there is nothing to prevent the designer from inventing new forms…which fall between traditional costume and scenery.[2]

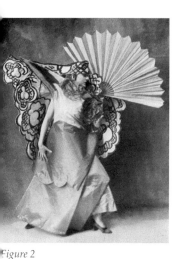

Figure 2

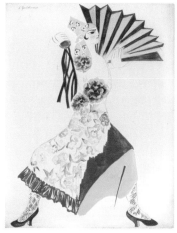

Figure 3

The city of Seville, with its blending of Moorish and Gypsy cultures, had captivated visitors from France since the nineteenth century. Diaghilev's company was no exception, resulting in two unrealized projects: *España* and *Triana*, choreographed by Massine to music by Maurice Ravel and Isaac Albéniz, respectively. Gontcharova conceived the costumes of Spanish dancers as mixed-media reliefs,

combining sewing and construction and incorporating the multiple points of view characteristic of Cubism (Figures 2 and 3). The artist's friend, Russian writer, musician, and dancer Valentin Parnak, described the effect:

Spanish women in dazzling shawls seemed to be encased in boxes. But a hidden movement could be felt in everything. The Spanish women of Gontcharova: cathedrals of lace and shawls in bloom.[3]

The drawing and rehearsal photograph of a dancer with a fan suggest Gontcharova's intentions. The advancing angles of the dancer's flounced skirt—layered in stiff folds over her splayed legs—and the flying form of the hand-painted lace shawl suggest the rhythmic energy of flamenco. Stretched taut in the same plane as the dancer's head, the shawl and the enormous fan would integrate the dancer with the setting of flowering trees and colorful banners.

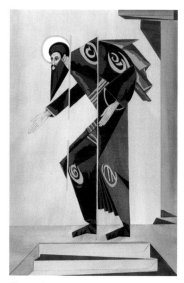

Figure 4

Similarly Rome, with its medieval churches, revived Gontcharova and Massine's shared interest in the Byzantine art of their native Russia. They created an additional unrealized ballet, *Liturgie*, in which Jesus, his apostles, and other sacred figures from the iconostasis of an Orthodox church came to life. Gontcharova reportedly proposed to fabricate the costumes in wood and copper, suggestive of an altar screen. The dancers were to wear stylized masks and their movements were to be determined by the construction of the costumes, as suggested in Gontcharova's drawings and a suite of pochoir plates of the costume design (Figure 4). Parnak explained:

Certain parts of the body (legs, arms) are linked to such a degree by the costume that they can make only one type of movement which serves to order the dance. For example, the right arm and the left leg are immobilized in an expressive gesture, while the left arm and right leg move freely at the expense of the other two.[4]

The dancers' feet served as percussion instruments, the only accompaniment to the ballet itself, although unison chants performed by a choir were envisioned between acts. Choreography, music, and design were conceived as an integral whole, expressing the ritual solemnity of the Orthodox liturgy and the sacred power of icons, in which saints are believed to be miraculously present. Gontcharova and Massine had conceived a ballet that was not only artistically daring and potentially sacrilegious, but also posed daunting technical and financial requirements. Like *España* and *Triana*, *Liturgie* was never developed past rehearsals. Gontcharova remained in France and designed additional productions for the Ballets Russes, including innovative productions co-designed with Larionov. However, in retrospect, she would never again enjoy such license to develop her artistic ideas to their logical conclusion in theatre production.

ALEXANDRA EXTER: COSTUME AS MOVEMENT

The ordinary stage with its backdrop and curtains was fraught with two problems of plastic discordance. First, the painted perspective and volume of flat decorations could not work together with the concrete volume of the actor's figure. Second, the motionless, painted background could not enter into rhythmic unity with the figures moving out in front. Consequently, the designers, despite their fanfare of colors, never achieved the desired harmony and wholeness of a single common impression.[5] —Alexandra Exter

Alexandra Exter tackled this "discordance" between flat, static, painted scenery and the three-dimensional bodies and movements of live actors in her earliest productions at Tairov's Kamerny Theatre in Moscow, where she returned in 1914 after almost a decade abroad in Paris and other cities. In a series of classic plays culminating in Shakespeare's *Romeo and Juliet* (1921), Exter pioneered a dynamic three-dimensional stage environment resembling a vibrant procession of Cubism. Scenery, props, and costumes were fully volumetric, like counter-reliefs, the non-objective constructions that Exter's Constructivist colleagues created in response to Cubism. With diagonal forms suggesting rotational movement in

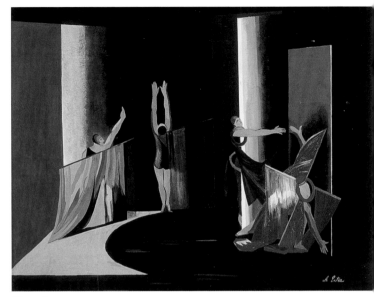

Figure 5

depth, Exter's costumes and scenery were compositionally dynamic. Moreover, the performers could interact with the scenery physically as well visually, an innovation crucial to the development of theatrical Constructivism in Russia and beyond.

Upon her definitive return to France in 1924, Exter realized her ideas in collaboration with Bronislava Nijinska, the Ballets Russes' former principal dancer and choreographer. Rejecting the mimetic movement and cumbersome costumes of Diaghilev's ballets, Nijinska founded her own companies, including Théâtre Choréographique Nijinska. Having embraced pure form in her own painting, Exter collaborated with Nijinska to realize analogous ideas on stage, in such non-narrative ballets as *Holy Études* (1925) and in the film project *La Fille d'Hélios (The Daughter of Helios)* (1927) (Figures 5 and 6). In these projects the dancers wore simple leotards or tunics, realizing Exter's ideas for functional "production garments" published in a 1923 essay, "In Search of New Clothing":

Right now, when the theater is studying every possible kind of movement…theatre should base its production clothing on the movement of the actor's body…. The fundamental condition of contemporary aesthetic should also be observed: respect for materials…. It [fabric] should be incorporated into distinct

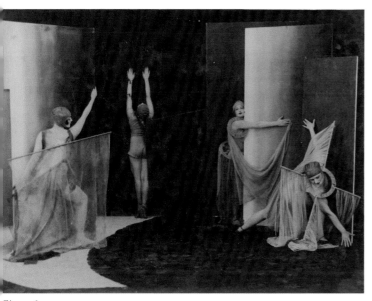

Figure 6

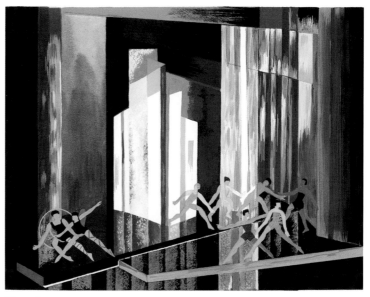

Figure 8

geometric forms, one or two, rarely three. Color should emerge from the design itself…. The very environment of Russia demands color—rich, primary colors.[6]

In *The Daughter of Helios*, Exter went beyond such projects as *Holy Études*, in which the dancers wore rectangular robes and circular headdresses. Instead, as Exter's drawing and a photograph reveal, the dancers manipulated drapes of translucent fabric, suspended from poles and rings, blurring distinctions between costume and scenery. In the Nijinska-Exter collaboration, the poles, rings, and fabric functioned as plastic elements articulating space, in the manner of the dynamic lines, circles, and planes in Exter's Constructivist paintings.

Exter is perhaps best known today through *Aelita Queen*

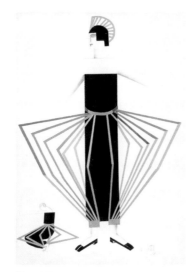

Figure 7

of Mars. Directed by Yakov Protazanov, this pioneering 1924 science fiction film showed what her costumes actually looked like in action. Exter utilized modern materials and engineering techniques to conjure up a world of atomic power and space exploration, the setting for a failed utopian revolution echoing the course of events in the Soviet Union. Exter's costume designs, which functioned as kinetic sculpture, rivaled the work of her Constructivist colleagues Alexander Rodchenko and Vladimir Tatlin. The costume for Aelita's servant (Figure 7) was an especially brilliant example. The staves of the skirt, anchored at the waist and ankles and hinged at the knees, collapsed and expanded, bent and straightened, with the movements of the actor. The action took place on multilevel platforms, connected physically by diagonal or circular staircases, and visually by soaring transparent pillars and curved suspended panels. Exter and her collaborator, scene designer Isaak Rabinovich, realized ideas she had articulated in "The Artist in the Theatre" (1919):

> *Free movement is the fundamental element of the theatrical act…. The artist may achieve this mastery over the dynamic action through architectonic constructions…. The action can be moved to a greater height by uniting the floor of the stage with*

61

the upper edge of the stage box by means of platforms, ladders, and bridges. This will give the actors a chance to display the maximum degree of dynamic action.[7]

In 1930 Exter published a portfolio of pochoir plates reproducing her theatre designs. Performers climb ladders, scale inclines, or dance on scaffolding. Beams of light crisscross the stage or dematerialize its surface with shimmering color (Figure 8). Including concepts too visionary to be realized on stage—even in circus or music hall, not to mention in legitimate theatre—these pochoir, like the international theatre exhibitions in which Exter contributed, extended her influence beyond Russia and France.

SONIA DELAUNAY: COSTUME AS POETRY

In 1913 Sonia Terk Delaunay entered the Bal Bullier (the Paris left bank ballroom she frequented with her French husband, the painter Robert Delaunay, and their artist and writer friends) wearing a *robe simultanée* of her own creation, a garment that proved to be her first performance design. Appliquéd with spiraling disks of spectral color, this dress exemplified the "simultaneous contrasts of colors"

Figure 9

characteristic of the Delaunays' version of Cubism. Verging on abstraction, the couple's paintings prompted Guillaume Apollinaire to call their style "Orphism" after the Greek god of music and poetry. It is not known if Robert wore his own "simultaneous suit" to the Bullier. In her "simultaneous dress," however, Sonia seemed to be one of the dancers in her paintings, in which couples are caught up in musical rhythms of the foxtrot, tango, and other ragtime dances of the day. Delaunay's venture into performance occasioned a journalistic account by Apollinaire and inspired a poem by Blaise Cendrars, "On Her Dress She has a Body," which concludes:

> *Belly*
> *Discs*
> *Sun*
> *And colors' perpendicular cries fall upon the things*
> *St. Michael's sword*
> *There are hands which extend*
> *There are in the train of the dress a beast,*
> *all eyes, all fanfares,*
> *all the habituées*
> *of the Bal Bullier*
> *And on the hip*
> *The poet's signature.*[8]

The opportunity to realize these ideas onstage came when Diaghilev invited the Delaunays to design the London revival of *Cleopatra* in 1918 (Figure 9). Liubov Tchernicheva, who mimed the title role, wore a version of Sonia Delaunay's "simultaneous dress" from the Bal Bullier. More exotic, the costume was also even more erotic, with the concentric circles of color emphasizing breasts and hips. Although he eschewed archaeological accuracy, the colors and patterns of Robert Delaunay's décor evoked Pharaonic art, with its inlays of gold, lapis, and carnelian.

Despite the success of *Cleopatra*, most of Sonia Delaunay's performance activity took place outside of established theatre companies. As a result of new friendships with members of the Paris Dada group, she participated instead in art world "soirées" and eventually used this model for her own activities as a fashion designer. The best-known collaboration was the staging of Tristan Tzara's *Le Coeur à Gaz (The Gas*

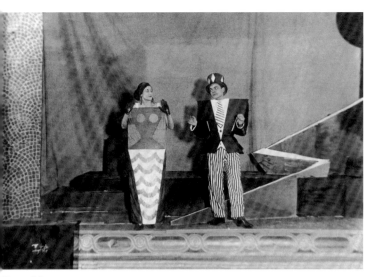

Figure 10

became graphic elements in their own right, as well as signifiers of meaning. This "curtain-poem" decorated the salon where the Delaunay's entertained their friends. She also used it as a cape or shawl, inspiring a new series of collaborations on *"robes poèms"* or "dress-poems." Tzara sent Delaunay the following lines, which she incorporated in a drawing published decades later in a suite of pochoir plates (Figure 12):

L'Ange a glissé sa main
Dans la corbeille d'oeil des fruits.
It arrête les roues des autos
Et le gyroscope vertigineux du coeur humain.

The Angel has slipped his hand
Into the basket, the eye of the fruit.
He arrests the wheels of the motor cars
And the human heart's dizzy gyroscope.[9]

Heart), the centerpiece of a Dada evening at the Théâtre Michel on July 6, 1923. Characters including Eye and Mouth (later identified, more conventionally, as Bride and Groom) declaimed verses in which words are freed from their usual meanings (Figure 10).

Delaunay's costume constructions are as one-dimensional as the characters' names. Isolated and fragmented letterforms are incorporated nonsensically in actors' costumes, recalling the tradition of free word poetry from the Futurists to the Dadaists. Tzara, who had pioneered "simultaneous poetry" at the Cabaret Voltaire in Zurich, was a master of this genre. When Delaunay published a lithograph of the costume design for the Dancer (Figure 11), she surrounded it with a cascade of upright and inverted "V's" and "Y's"—the same letters as in the original costume/production photographs. Significantly, the lithograph is titled *Zaoum*, what is undoubtedly a reference to Zaum, the trans-rational poetry of Velimir Khlebnikov, Aleksei Kruchenykh, and other Russian Futurist writers.

Poets proved to be Delaunay's closest friends and collaborators, inspiring her informal design and performance activities. In 1922 she embroidered a poem by Philippe Soupault onto a silk curtain, creating a composition in which—in the tradition of Apollinaire's caligrammes—letterforms

Figure 12

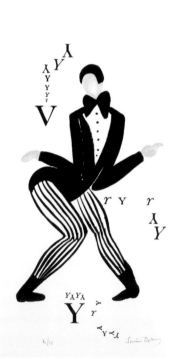

Figure 11

In reduced financial circumstances after the First World War, Sonia Delaunay supported her family, and her husband's painting career, by developing her talents in textile and fashion design. Although anathema to the Dadaists, this commercial activity had the ironic effect of unifying art and life, the motivating force behind her friends' own performance activities. It is as an innovative fashion and interior designer, who staged runway shows and fashion shoots to promote her work, that Delaunay is perhaps best known today.

LESLEY DILL AND THE LEGACY OF THE AVANT-GARDE

That this discussion focuses on three women artists—Gontcharova, Exter, and Delaunay—reflects the strengths of the McNay's Tobin Collection of Theatre Art. This selection also presents an accurate picture of an extraordinary moment in Russia when women felt empowered to think and create as equals to their male colleagues. In France, Gontcharova, Exter, and Delaunay continued to pursue careers as painters and printmakers, often without public recognition. Yet they were acclaimed for their "applied art" work not only in theatre, but also in fashion, interior, and graphic design. Amidst the women's movement of the 1970s, visual artists began to claim textiles as a "fine arts" medium along with other materials and techniques associated with "women's work." Artists often adopted clothing as a subject matter for exploring women's experiences in society, not only in painting and sculpture but also, and perhaps most powerfully, in performance. In recent decades, the focus on clothing has expanded to encompass broader explorations of the body and of identity. This is a tradition in which Lesley Dill works today, creating garments that stand on their own as sculpture in the context of gallery and museum installations.

Lesley Dill's work takes on its full meaning, however, in performance. Like much of the performance art created by visual artists since the 1960s, Dill's includes theatrical elements. With the exception of *Divide Light* (2008), conceived as a chamber opera and presented in a performing arts center, her work is not, strictly speaking, theatre. Nor is Dill a theatre designer as that profession is commonly practiced today in the United States, where costume and scene design are often separate specialties and designers are often charged with implementing the director's creative vision. Dill not only designs, but also conceives, writes, and directs her performances and also collaborates on films that are parallel art works, not simply historical documents. In these respects, Dill's work recalls not only the artistic concerns, but also the professional practices of the early twentieth-century avant-garde. Dill, however, exercises a degree of artistic control that her predecessors Gontcharova, Exter, and Delaunay could only have dreamed of.

FOR FURTHER READING

Bellow, Juliet. *Modernism on Stage: The Ballets Russes and the Parisian Avant-Garde*. Burlington: Ashgate Publishing Company, 2013.

Bowlt, John E. and Matthew Drutt, editors. *Amazons of the Avant-Garde: Alexandra Exter, Natalia Goncharova, Liubov Popova, Olga Rozanova, Varvara Stepanova, and Nadezhda Udaltsova*. New York: Solomon R. Guggenheim Museum, 2000.

Goldberg, RoseLee. *Performance Art from Futurism to the Present*. Third edition. London: Thames & Hudson, 2011.

Kovalenko, Georgy. *Alexandra Exter*. 2 vols. Moscow: Moscow Museum of Modern Art, 2010.

Montfort, Anne and Cécile Godefroy. *Sonia Delaunay*. London: Tate Publishing, 2015.

Sharp, Jane Ashton. *Russian Modernism between East and West: Natal'ia Goncharova and the Moscow Avant-Garde*. Cambridge and New York: Cambridge University Press, 2006.

Van Norman Baer, Nancy with contributions by John E. Bowlt, et al. *Theatre in Revolution: Russian Avant-Garde Stage Designs, 1913-1935*. New York: Thames and Hudson in conjunction with The Fine Arts Museums of San Francisco, 1992.

FIGURES

ENDNOTES

1 Natalia Gontcharova, Letter to the Editor of *Russian World*, February 13, 1912, translated in *Amazons of the Avant-Garde: Alexandra Exter, Natalia Gontcharova, Liubov Popova, Olga Rozanova, Varvara Stepanova, and Nadezhda Udaltsova*, edited by John E. Bowlt and Matthew Drutt (New York: Solomon R. Guggenheim Museum, 2000), 312.

2 Nathalie Gontcharova and Michel Larionov, "Serge de Diaghilew et l'évolution du décor et du costume de ballet," in *Les Ballets Russes: Serge de Diaghilew et la décoration théâtrale*, edited by Pierre Vorms (Belves: Pierre Vorms, 1955), 38. Translation by the author.

3 Valentin Parnak, *Gontcharova, Larionow: L'Art Décoratif théâtrale moderne* (Paris: Editions La Cible, 1919), 13. Translation by the author.

4 Parnak, 13. Translation by the author.

5 Alexandra Exter, in conversation with Philippe Goziason, "The Artist in the Theatre" (1919), in *Amazons of the Avant-Garde*, 302.

6 Alexandra Exter, "In Search of New Clothing" (1923), translated in *Amazons of the Avant-Garde*, 302.

7 Exter, "The Artist in the Theatre," translated in *Amazons of the Avant-Garde*, 303.

8 Blaise Cendrars, "On Her Dress She Wore a Body" (1914), translated in Arthur A. Cohen, *The New Art of Color: The Writings of Robert and Sonia Delaunay* (New York: Viking Press, 1978), 182.

9 Tristan Tzara, "Poem for a Dress by Madame Sonia Delaunay," translated in Jacques Damase, *Sonia Delaunay: Rhythms and Colors* (Greenwich: New York Graphic Society; London: Thames & Hudson, 1972), 170.

Lesley Dill Biography

Lesley Dill is recognized for using a variety of materials, techniques, and approaches to explore themes of language, the body, and transformational experience. Her work focuses on human beings—still, speaking, or singing—and their relationship to language. Dill's imagery is almost always accompanied by text, often derived from literary figures including poets Emily Dickinson, Salvador Espriu, and Tom Sleigh, among others. She sees words as revelatory through visual depiction, or incantation, prayer, and song. For the artist, words are a force field of connection between social space and personal interiority.

Dill was born in Bronxville, New York, in 1950 and raised in Maine. She received a Bachelor of Arts from Trinity College, Hartford, Connecticut, in 1972; a Master of Arts in Teaching from Smith College, Northampton, Massachusetts, in 1974; and a Master of Fine Arts from Maryland Institute College of Art, Baltimore, in 1980. Soon after, she moved to New York, where she emerged prominently as a sculptor and multimedia artist, widely exhibiting her work and, since 1993, conceiving and creating performances. *Divide Light*, which premiered in August 2008 at the Montalvo Arts Center, Saratoga, California, is a full-scale opera based on the poems of Emily Dickinson. A film of the opera by Ed Robbins premiered in New York in April 2009.

Lesley Dill's work is found in numerous collections including the Art Institute of Chicago, Illinois; The Cleveland Museum of Art, Ohio; Denver Art Museum, Colorado; High Museum of Art, Atlanta, Georgia; Kemper Museum of Contemporary Art, Kansas City, Missouri; Library of Congress, Washington, District of Columbia; McNay Art Museum, San Antonio, Texas; The Metropolitan Museum of Art, New York; Museum of Modern Art, New York; National Museum of Women in the Arts, Washington, District of Columbia; The Nelson-Atkins Museum of Art, Kansas City, Missouri; New Orleans Museum of Art, Louisiana; Orlando Museum of Art, Florida; Pennsylvania Academy of the Fine Arts, Philadelphia; Rhode Island School of Design, Providence; Smith College Museum of Art, Northampton, Massachusetts; Spencer Museum of Art, The University of Kansas, Lawrence; Toledo Museum of Art, Ohio; Virginia Museum of Fine Arts, Richmond; Weatherspoon Art Museum, Greensboro, North Carolina; Whitney Museum of American Art, New York; and Yale University Art Gallery, New Haven, Connecticut.

Among other honors, Dill received an award from Anonymous Was A Woman in 2008, a Painters and Sculptors Grant from the Joan Mitchell Foundation in 1996, and a Visual Artists Fellowship in Sculpture from the National Endowment for the Arts in 1990.

Lesley Dill lives and works in Brooklyn, New York. She is represented by Arthur Roger Gallery, New Orleans, Louisiana.

WEBSITE
lesleydill.net

OPERA
dividelight.com

SOCIAL MEDIA
f LesleyDill

McNAY PERFORMANCE
drunkwiththestarryvoid.com

Lesley Dill: Performance as Art is published on the occasion of an exhibition of the same title, presented at the McNay Art Museum, San Antonio, Texas, June 10–September 6, 2015. This exhibition was organized by the McNay Art Museum.

Library of Congress Cataloging-in-Publication Data

Lesley Dill : performance as art / René Paul Barilleaux, Jody Blake.

 pages cm

 Issued in connection with an exhibition held June 10-September 6, 2015, McNay Art Museum, San Antonio, Texas.

 Includes bibliographical references.

 ISBN 978-0-916677-59-6 (pbk. : alk. paper) 1. Dill, Lesley, 1950---Exhibitions. 2. Performance art--United States--Exhibitions. I. Barilleaux, René Paul. II. Blake, Jody, 1953- III. Dill, Lesley, 1950- Works. Selections. IV. McNay Art Museum.

 NX512.D55A4 2015

 700.92--dc23

 2015011864

Published by the McNay Art Museum
mcnayart.org

Designed by Soleil Advertising, Inc.
Edited by Diana Lyn Roberts
Printed and bound in Canada

IMAGE CAPTIONS

Front cover: *Divide Light*, 2008; Performer: Jorge Morejon

Inside front cover: *Divide Light*, 2008

Page 3: Lesley Dill with Word Puppets

Page 4: *Sometimes I Feel Skinless*, 1995

Page 7: *I Dismantle*, 2003

Page 8: *Drunk with the Starry Void*, 2012

Page 11: Graphicstudio, University of South Florida, performance with students, 1996

Page 12: Books of Emily Dickinson's poetry

Page 14 (left and right): *Paper Speaking Dress*, 1993

Page 15 (top row): *Leave Me Ecstasy*, 1997

Page 15 (middle row, left to right): *Poem Eyes*, 1995; *Rapture's Germination*, 2010; *Dreamer*, 1998; *Dada Poem Wedding Dress*, 1994

Page 15 (bottom row): *Ecstasy (Kneeling Figure)*, 2003

Page 16 (left to right): *Head*, 2003; *Poem Suit of Armor*, 1993; *Hinged Poem Dress*, 1991; *Hinged Poem Dress* (opened), 1991

Page 17 (top row, left to right): *The Joy*, 2010; Graphicstudio, University of South Florida, performance with students, 1996; *Hunger and Desire*, 1998; *A Word Made Flesh (Throat)*, 1994

Page 17 (bottom row, left to right): *Poem Body Healing Diagram*, 1995; *Profound Precarious Property*, 1996

Page 18 (top): *Sometimes I Feel Skinless*, 1995

Page 18 (bottom): The University of Memphis, performance with students, 1995

Page 19 (left to right): *Poem Dress for a Hermaphrodite*, 1995; Language House, India; Ancient Hindi Prescription Drawing

Page 20 (all): *Divide Light*, 2008

Page 21 (left to right): *Heaven Heaven Heaven Hell Hell Hell: Encountering Sister Gertrude Morgan and Revelation*, 2010; *Faith & The Devil*, 2012

Page 22 (top row, left to right): *Blind Desire*, 2012; *Faith & The Devil*, 2012

Page 22 (middle row; bottom row, left and right): *Drunk with the Starry Void*, 2012

Page 23 (top row, left to right): *Ecstasy Gown*, 2014; *Only*, 2004

Page 23 (bottom row): *Tongues on Fire: Spiritual Sing*, 2001

Page 24 (top row, left to right): *I Heard a Voice*, 2002; Ars Nova Singers

Page 24 (middle row): Lesley Dill and Richard Marriott

Page 24 (bottom row, left and right): *I Dismantle*, 2003

Page 25 (top row): Ed Robbins

Page 25 (middle row, left to right): *Labor of Love*, 2014; Laura Oxendine and Lesley Dill

Page 25 (bottom row): Pamela Ordoñez

Page 26: *Divide Light*, 2008

Page 66: Lesley Dill

Page 67 (left to right): Claudia costumed as Aki; Aki costumed as Claudia

Inside back cover: *Vision Catcher*, 1995. Collection of the McNay Art Museum, Museum purchase with funds from the McNay Contemporary Collectors Forum, 2006.53

PHOTOGRAPHY CREDITS

Pages 3, 66: George Woodman

Pages 4, 7, 18 (top), 19 (middle and right), 24 (bottom row, right), 44 (all), 45 (all), 47: Ed Robbins

Pages 11, 17 (top row, second from left): Hank Hein

Page 20 (bottom row, right): Rena Buchgruber

Pages 21 (left), 25 (middle row, right): Arthur Roger Gallery, New Orleans, Louisiana

Page 21 (right): Clay Center for the Arts & Sciences, Charleston, West Virginia

Pages 24 (bottom row, left), 46 (all): George Adams Gallery, New York

Page 25 (top row): Nicholas Kristoff

Pages 25 (middle row, left), 52 (all), 53 (all): Simon Dove

Page 25 (bottom row): Heidi Zumbrun/JACK ALICE

Pages 30, 31 (all): Frank Franka

Pages 38 (top), Page 39 (left and right): Paula Court

Page 38 (bottom): Dona McAdams